1945–1975

THE VIETNAM WAR

NEW YORK
HISTORICAL
SOCIETY
MUSEUM & LIBRARY

MAKING HISTORY MATTER

New-York Historical Society, New York, New York
In association with D Giles Limited, London

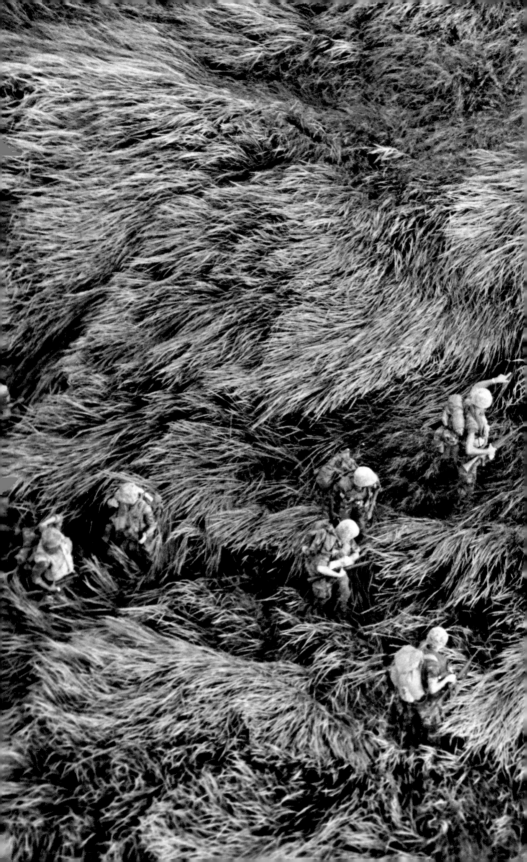

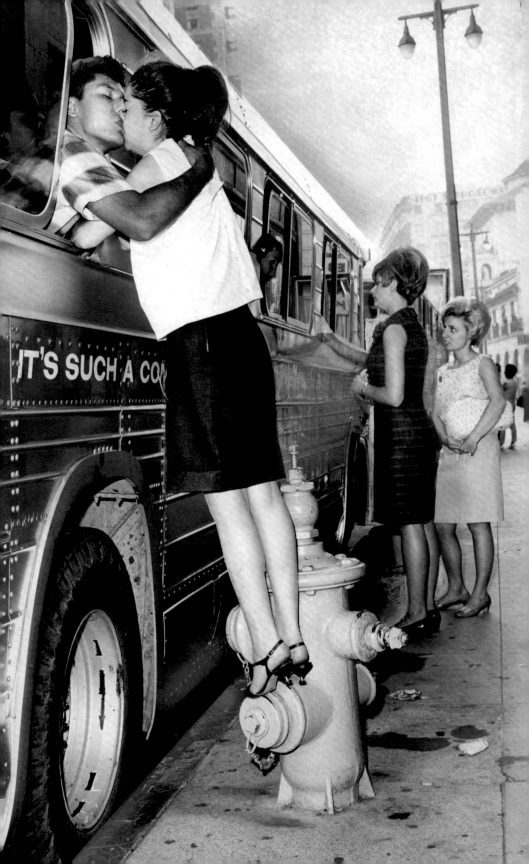

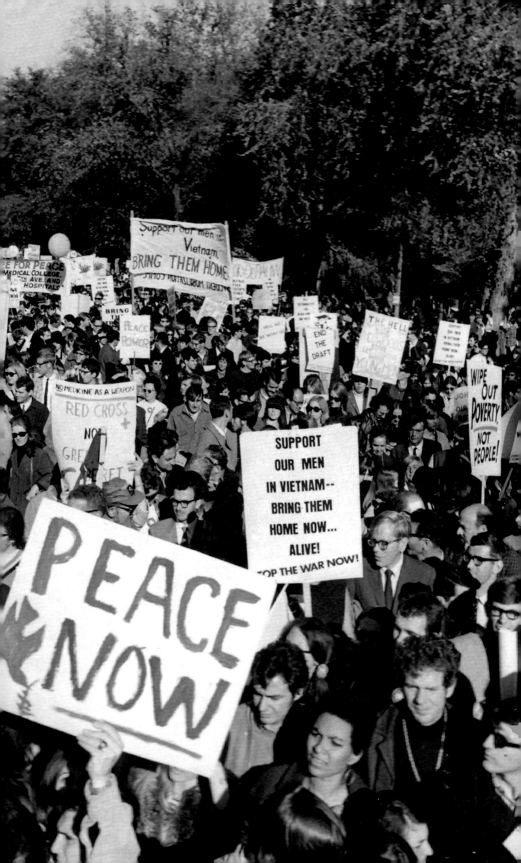

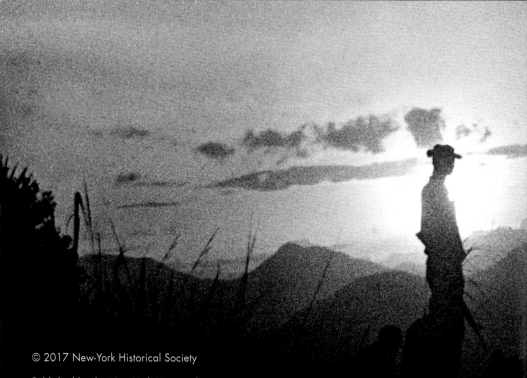

Published by the New-York Historical
Society, New York, New York, in association
with D Giles Limited, London, on the
occasion of the exhibition *The Vietnam War
1945–1975* on display from October 2017
to April 2018.

First published in 2017 by GILES
An imprint of D Giles Limited
4 Crescent Stables, 139 Upper Richmond Road
London, SW15 2TN, UK
www.gilesltd.com

ISBN: 978-1-907804-77-9

For the New-York Historical Society:
Written by David Parsons, Marci Reaven,
and Lily Wong
Image and rights coordinator: Dayna Bealy

For D Giles Limited:
Copy-edited and proof-read by Jodi Simpson
Designed by Alfonso Iacurci
Produced by GILES, an imprint of D Giles
Limited, London
Printed and bound in Hong Kong

Library of Congress Cataloging-in-
Publication Data
Names: New-York Historical Society. |
 D.Giles Limited.
Title: The Vietnam War, 1945-1975 / New-
 York Historical Society, New York,
 New York ; in association with D. Giles
 Limited, London.
Description: New York : New-York Historical
 Society, 2017.
Identifiers: LCCN 2016050764 | ISBN
 9781907804779 (pbk. : alk. paper)
Subjects: LCSH: Vietnam War, 1961-1975.
Classification: LCC DS557.7 .N385 2017
 | DDC 959.704/3–dc23
LC record available at https://lccn.loc.
 gov/2016050764

The Vietnam War exhibition received major
support from the National Endowment for
the Humanities and the Institute of Museum
and Library Services. Additional funds were
provided by private donors in honor of
Gunner's Mates Simpson, Wicks, and Von
Essen, once of the USS *Hornet*.

Contents

Pages 2–3: *Infantrymen of the 3rd Battalion, 5th Marines, in elephant grass during Operation Meade River*, 1968. National Archives at College Park, MD

Page 4: *Goodbye kiss for inductee*, 1966. Herald-Examiner Collection / Los Angeles Public Library

Page 5: *March on the Pentagon*, 1967. Photograph, Theodore Hetzel / Swarthmore College Peace Collection

Pages 6–7: *Vietnam sunset, LRRPs*, 1968. Photograph, Paul T. Owen

Men of 2nd Battalion, 7th Marines, move along rice paddy dikes in search of the enemy, 1965. National Archives at College Park, MD

President's Foreword

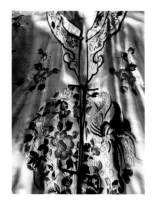

I was born in 1953, three months before the day of the signing of the armistice that ended the Korean War. My uncle, a U.S. army soldier stationed in the Philippines during the war, returned home to New York that summer, bringing with him a number of souvenirs. Among them was an exquisite embroidered silk kimono. A bachelor at the time, my uncle gave the kimono to my mother, his sister-in-law. A few years later, my mother passed the garment along to me. For the rest of my childhood it remained my favorite article of clothing in which to play "dress up" with my friends.

If the souvenir kimono was in any way a signifier of the landscape of global politics in the early years of the Cold War or a harbinger of American involvement in Vietnam, as a child I could not have been less aware. But clothing, as I now understand, can be a revealing sign. The kimono, made of Chinese silk cut in the Japanese style and brought back to New York by an American soldier stationed in the Philippines during the Korean War told a story that all at once looked back on a long and complex global history and foreshadowed the polemical battles that would, during the Vietnam War era, take place in American homes—including my own.

Historians have by now painstakingly explored the struggle between the world's most powerful nations that moved Vietnam to the center of global affairs in the era of the Cold War. They have found hitherto unknown or unexamined connections between choices made as early as 1945 to the key decisions taken by U.S. and Vietnamese leaders in the years leading up to all-out war. And they have lectured and written about the wide-ranging and deeply profound public discourse that continues to inform debates about national policy and America's role on the world stage today. They have also cast their nets far back in time to place Vietnam within a much longer history of enmities and alliances in the region—a history that is, if not fully explanatory, at least richly descriptive of the centuries of invasion,

occupation, and cultural exchange that the fabric, design, and provenance of my uncle's Korean War souvenir signified.

But the complex story that historians have lectured and written about has rarely been told in the public history setting of a major museum. The New-York Historical Society's exhibit *The Vietnam War 1945–1975* and this companion book are part of a larger educational initiative to introduce the broadest possible public to what historians— from differing vantage points and perspectives—have discovered and concluded about the causes, conduct, and consequences of the Vietnam War. Part of the power of an exhibition, and where public history diverges from historians' lectures and written work, is the museum's ability to dramatically present, through curated displays of documents, art, artifacts, and media, the voices of many and varied historical actors at particular moments in time. The voices heard throughout the galleries of New-York Historical's Vietnam War show and in this book capture, as public history does at its best, the moving experiences and insightful accounts of extraordinary individuals.

We are proud of our work on *The Vietnam War 1945–1975*, as well as our institution's numerous and ongoing initiatives to underscore why history matters so much. Throughout the course of this project we have posed the question, to ourselves and to our scholarly advisers, of what the Vietnam War might mean for our visitors and the readership of this book, including hundreds of thousands of individuals born well after the end of the Vietnam War—an audience for whom the mid-twentieth century might as well be ancient history. Our hope is that this project, developed in consultation with political and military historians of the war, veteran servicemen and nurses, Southeast Asian refugees, anti- and pro-war activists, and civilian and military consultants within Vietnam, will lead to deep and productive thinking about issues that were discussed and debated during the Vietnam War, which still resonate today: Americans' responsibilities and duties as citizens; the meaning of patriotism, loyalty, and morality; the authority of government. The Vietnam War tested the parameters of American democracy, sometimes expanding and sometimes contracting in the wake of bitter and tragic events. And yet the Vietnam War and its aftermath provide powerful testimony to the depth and resilience of the foundational aspects of American life, an important lesson in present times.

Telling the story of the Vietnam War has reopened a painful chapter for many of us, reminding us of the polarizing nature of the conflict that pulled Americans in different directions and divided families across generations. My own family is a case in point. In 1966, my grandfather, a proud World War I veteran and father of the uncle who served during the Korean War as well as my father, gave me a poster of an American flag emblazoned with the motto "Support Our Boys in Vietnam." When my parents found the poster taped to my bedroom wall they furiously demanded that I immediately take it down. My mother and father were among the Vietnam War's earliest and most vehement opponents. But in my large and otherwise

close-knit family of grandparents, uncles, aunts, and cousins on both maternal and paternal sides, they were alone in their views right up to the end of the war.

This project owes its greatest debt of gratitude to my colleague, Marci Reaven, New-York Historical's Vice President for History Exhibitions and curator of *The Vietnam War 1945–1975.* Our institution is lucky—and I most particularly—to count on such enormous talent, insight, and intelligence. New-York Historical's Board of Trustees, led by Chair Pam Schafler, Executive Committee Chairman Roger Hertog, and Vice Chair Richard Reiss, has supported our work throughout, with ideas, suggestions, and advice, as well as financial resources. I want to single out for special thanks New-York Historical Trustee James Grant, whose first-hand experiences in the Vietnam War and appreciation of wartime friends, some of whom lost their lives, have added a personal dimension to our work.

We are thrilled and grateful to be the recipient of two grants from the National Endowment for the Humanities for both the planning and implementation of this project. I want to thank NEH Chairman William "Bro" Adams and NEH Director of the Division of Public Programs Karen Mittelman. The exhibition's public education programs are generously supported by the Institute of Museum and Library Services. Additional funds have been provided in honor of Gunner's Mates Simpson, Wicks, and Von Essen, once of the USS *Hornet,* by James Grant, Bridgewater Associates, Harlan Batrus, Stifel, and Karen and Paul Isaac. We wish to express our heartfelt appreciation to these and all other funders of the *Vietnam War 1945–1975* exhibition.

Louise Mirrer, Ph.D.
President & CEO
New-York Historical Society

Curator's Note

Working on this project about the Vietnam War has been an honor for all of us. Our hope is that the book and exhibit foster exploration, remembrance, discussion, and understanding of the war's events, participants, and effects.

We would like to thank all the individuals who have shared their knowledge and insights with us, as well as those whose writings, recordings, and archival efforts have created such a powerful historical record.

My co-authors and I owe a huge debt of gratitude to the scholars of the war with whom we have consulted repeatedly during the preparation of this book and exhibit. They are: Christian Appy, Beth Bailey, Carolyn Eisenberg, Todd Gitlin, Fredrik Logevall, Mark Moyar, Philip Napoli, Erik Villard, and Marilyn Young. We could not have asked for more generous and knowledgeable teachers, but any mistakes are fully our own.

Others have helped us enormously by sharing their photographs, artifacts, and personal experiences. Our many thanks to Art and Lee Beltrone of the Vietnam Graffiti Project, Barbara Chiminello, Joe Corrigan, John and Judy Day, Don Fedynak, Doug Hotstetter, the family of Le Anh Hao, Mike Locker, James McNamara, Paul Owen, Glenn Pontier, Robb Ruyle, Bob Walkowiak, and Dominique Zeppetello.

Still others have assisted in countless additional ways to create an account that seeks to honor all the people caught up in the cataclysmic events of the war years. Our appreciation to Florentine Films, and to Dang Hoa Ho, Matt Huynh, Cynthia Lee, Stuart Lutz, Ann Meyerson, Nguyen Minh Y, Ngo Thanh Nhan, Merle Ratner, Clare Richfield, Nick Tanis, Tran Huu Chat, Tran Thi Van; the organizations Legacies of War, Mekong NYC, Minnesota History Center, the Veterans History Project at the Library of Congress, and the Vietnam Archive at Texas Tech University; and the many colleagues in other institutions who generously loaned us objects.

Finally, deepest thanks to the New-York Historical Society Trustees and President Louise Mirrer, to the project's generous funders, to my co-authors and curatorial collaborators Lily Wong and David Parsons, to New-York Historical's terrific staff, with grateful mention

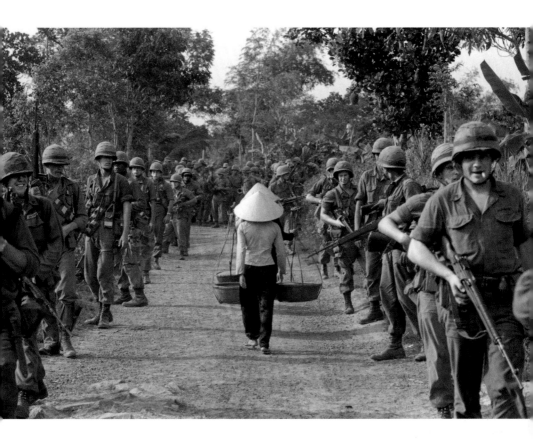

to Dayna Bealy, Bekah Friedman, Kira Hwang, Maggie Lee, Cecilia Porras, Gerhard Schlanzky, Dottie Teraberry, and Mike Thornton, and to our publisher D Giles Limited.

We hope that our collective efforts contribute to a fuller understanding of the important questions, concerns, hopes, terrors, and considerations for the future embodied by this long, contentious, and heartrending war.

Marci Reaven, Ph.D.
Vice President for History Exhibitions
New-York Historical Society

U.S. Marines encounter Vietnamese villagers while conducting a reconnaissance mission west of Danang, 1965. Henri Huet / Bettmann / Getty Images

Monsoon season, Vietnam, ca. 1950s. Photograph, Everette Dixie Reese. Courtesy of George Eastman Museum and Alan Reese.

INTRODUCTION
1945–1953

The prelude to America's long war in Vietnam began in earnest in 1950. That year, President Harry S. Truman started sending military aid to support France in its effort to recolonize Vietnam, Laos, and Cambodia. The president and his administration believed that France's continued presence in Indochina would stop the spread of communism in Asia. Success for France would be a shared victory for their side in the Cold War.

At its core, the Cold War was a prolonged period of political and military tension between two rival superpowers, the United States and the Soviet Union. During World War II, they had allied to defeat Nazism and fascism. But after 1945, the two nations' ideological, economic, and political differences led them to look at each other with deep suspicion. They competed for influence in regions around the globe, including former colonial strongholds where movements for national independence had gained traction in the chaotic aftermath of world war.

After the Soviet Union successfully tested an atomic bomb in 1949, tension between the two superpowers increased dramatically. The United States no longer held a monopoly on nuclear weapons. That same year, a communist victory in China's civil war further alarmed American leaders, who vowed to stop communism from spreading to the smaller nations of Asia. When North Korea invaded South Korea in 1950, the United States organized and led a United Nations coalition to fight the communist forces. The result was a bloody war that ended in stalemate three years later.

In this Cold War political environment, American politicians, school teachers, television and radio programs, newspapers, and motion pictures all reinforced the message that communism was not only contrary to the nation's values of individual freedom and democracy, but also predatory, aggressive, and in need of military containment. Stopping the spread of communism became a central component of American politics and the dominant feature of its foreign policy.

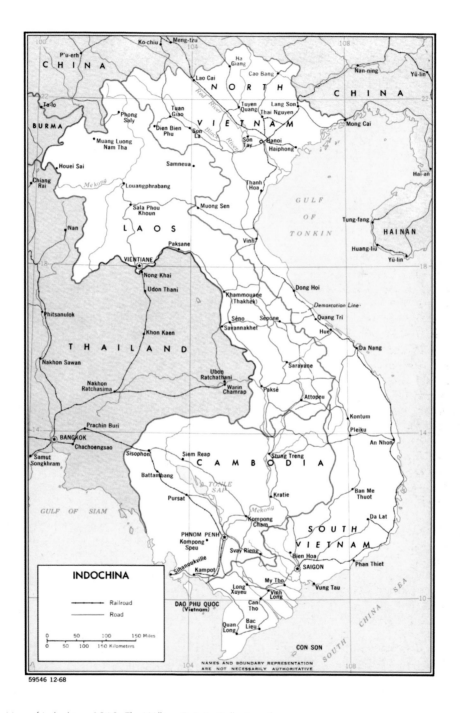

Map of Indochina, 1968. The William E. Potts Collection, the
U.S. Army Military History Institute, Carlisle Barracks, Pennsylvania

17

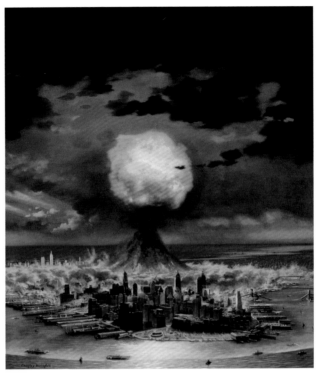

Chesley Bonestell, *Atom Bomb Hits New York City*, 1950.
New-York Historical Society. Reproduction courtesy of Bonestell LLC

"Hiroshima, U.S.A."

Four years after the United States dropped atom bombs on the Japanese cities of Hiroshima and Nagasaki, the Soviet Union successfully tested its own atom bomb. Fear of an apocalyptic nuclear war between the Cold War superpowers gripped populations around the world.

Chesley Bonestell's striking painting *Atom Bomb Hits New York City*, featured on the cover of *Collier's* magazine on August 5, 1950, reflected these fears. The story it accompanied, provocatively titled "Hiroshima, U.S.A.," presented a fictional account of an atom bomb explosion in New York City: "Great waves of purple and pinkish brown billowed across the city. Hundreds of feet high, they surged up like an angry sea; the powdered ruins of thousands of brownstone tenements. And beneath and beyond the waves glowed the ominous red of fire."

Nuclear weapons were never used for fear of mutual destruction. But this did not stop the U.S. and Soviet Union from opposing each other in "limited" wars around the globe.

The Korean War

The North Korean invasion of South Korea in 1950 tested the Truman administration's commitment to contain communism. Just a few years earlier, the president had argued that the nation must be willing to intervene in faraway, regional conflicts that did not directly involve the United States. Now he said, "An act of aggression such as this creates a very real danger to the security of all free nations."

Five days after the North Korean attack, Truman sent American ground forces to South Korea on his own authority, without a congressional declaration of war. That same day, the first U.S. transport planes arrived in Vietnam with military aid for the French.

American troops formed the bulk of United Nations forces in Korea. They fought alongside South Koreans to expel the North Koreans, who were supported by the Soviet Union and China. Then, determined to defeat the communists altogether, UN troops crossed the 38th parallel into North Korea. As the battle advanced north to the Chinese border, it triggered China's direct entry into the war. In bitter winter conditions and under intense counter-attack, UN forces fell back. Fighting continued for three years, at great human cost on all sides. In 1953, the conflict ended in stalemate with the original border maintained.

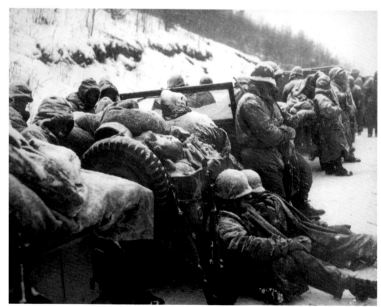

U.S. Marines await orders at the Chosin Reservoir, December 1950. Photograph, Frank C. Kerr / National Archives at College Park, MD

19

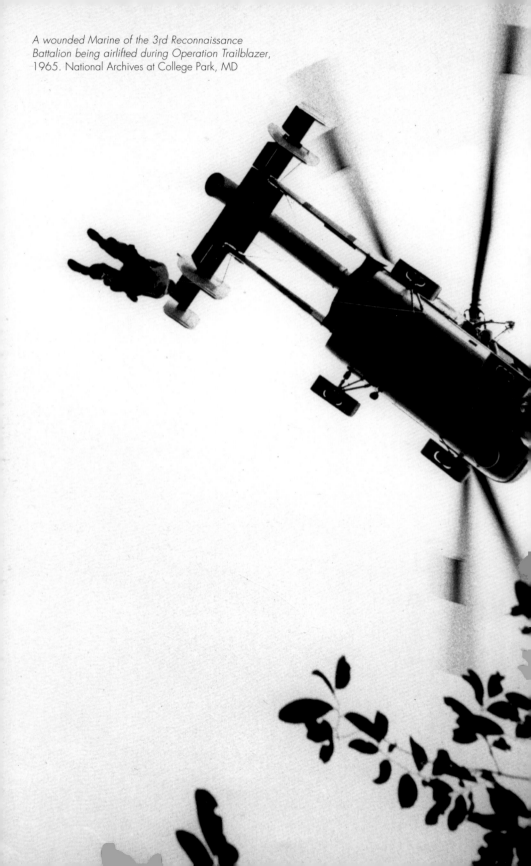

A wounded Marine of the 3rd Reconnaissance
Battalion being airlifted during Operation Trailblazer,
1965. National Archives at College Park, MD

WAR BEGINS 1954–1965

"You have a row of dominoes set up, you knock over the first one, and what will happen to the last one is the certainty that it will go over very quickly. So you have a beginning of a disintegration that would have the most profound influences."

– President Dwight D. Eisenhower, April 1954

When Eisenhower used this metaphor to discuss the strategic importance of Southeast Asia, he could hardly have known how ubiquitous the "domino theory" would become. But the image of nations falling to communism as surely as cascading dominoes powerfully supported the president's underlying message: local revolutions must be suppressed before they sparked chain reactions. For Eisenhower and his advisers, one domino in danger of falling was Vietnam.

Vietnam had been independent for nearly a millennium when France invaded and colonized its lands in the 1850s. Over subsequent decades, Vietnamese opposed to French domination drew upon the founding ideals of other countries—including the United States and the Soviet Union—to support their claims for freedom. During the upheaval of World War II, when Japan seized control of Indochina, Ho Chi Minh, a nationalist and communist, founded and led the League for Vietnamese Independence, known as the Viet Minh. While building a guerilla army to fight for liberation, the Viet Minh briefly cooperated with U.S. intelligence operatives against the Japanese occupiers.

When World War II ended in 1945, Ho Chi Minh declared Vietnam's independence. France rejected the Vietnamese claim, and instead sought to regain control. A year later, the two sides were at war. Fearing that a Viet Minh victory would result in a communist-led Vietnam, the U.S. funded France's military campaign.

In the spring of 1954, after seven-plus years of bitter fighting, the Viet Minh defeated the French at the battle of Dien Bien Phu, convincing France to sue for peace. Negotiations held in Geneva, Switzerland, temporarily split Vietnam into two separate zones at the 17th parallel. Internationally monitored elections were to reunify the country within two years. In the interim, the north was led by communist Ho Chi Minh, and the south by anti-communist Ngo Dinh Diem. The election, however, never took place. Diem, with U.S. support, refused to abide by the terms of the Geneva Accords. The temporary division at the 17th parallel hardened into a de facto border.

In the United States, a small but growing number of critics questioned whether the cancellation of elections contradicted America's stated values of democracy and self-determination, and whether the Diem experiment could survive in the long term. But

the Eisenhower administration asserted that North Vietnam would sabotage the elections and that keeping South Vietnam free of communism was a matter of vital national interest.

Presidents John F. Kennedy and Lyndon B. Johnson followed the path that Eisenhower had blazed, even as they privately questioned the prospects in South Vietnam and the ultimate importance of the struggle to U.S. and Western security. Kennedy's administration shored up South Vietnam's government and army with money, weapons, and American military advisers in order to contain a rising insurgency against Diem. When Diem was assassinated in a U.S.-approved coup shortly before Kennedy's own assassination in 1963, the insurgent forces escalated their attacks.

Johnson took office determined to prevail in Vietnam but also eager to focus on his domestic agenda. In August 1964, following a confrontation between U.S. and North Vietnamese boats in the Gulf of Tonkin, Johnson and his aides convinced Congress to pass a resolution that gave the president open-ended power to wage a wider war in Vietnam. By March 1965, American Marines had landed on South Vietnamese shores, North Vietnamese supplies and troops were moving down mountain and jungle paths to South Vietnam, and U.S. jets were bombing targets in North and South Vietnam and neighboring Laos. America's political commitment was turning into full-fledged war.

On July 28, 1965, Johnson announced that the crisis in Vietnam would require a sharp increase in military manpower. The president ordered the Selective Service System, the agency responsible for military conscription, to double the number of draft calls to nearly 35,000 young men each month. Johnson relied on the draft to fill the ranks because he feared that calling up the military reserves—typically composed of older, more established men—would draw unwanted attention to the war's escalation. By the end of 1965, 180,000 U.S. troops were on the ground in South Vietnam.

By then, the U.S. had been involved militarily in Vietnam for fifteen years. Some Americans were asking, How would we achieve victory in Vietnam? A smaller number asked, Should we be in Vietnam at all?

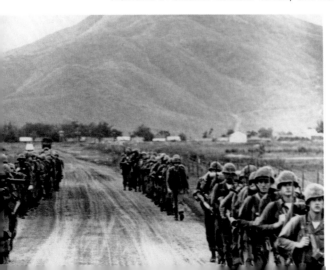

Marines marching near Danang, 1965. National Archives at College Park, MD 23

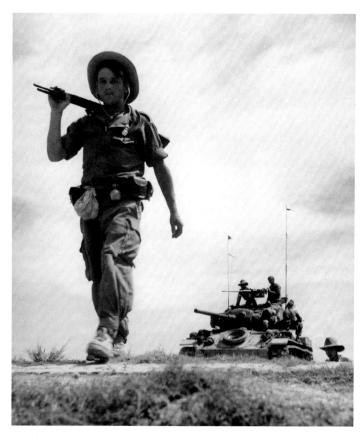

French Foreign Legionnaires with a U.S. tank in South Vietnam, ca. 1954. National Archives at College Park, MD

Supporting the French War in Indochina

In the early 1950s, the United States gave the French substantial American aid in their fight to retain colonial control over Vietnam. Already battling communists in Korea, President Truman believed U.S. support of France's war efforts would be crucial to halting communism's spread in Asia. The American tank shown here was part of the massive U.S. military aid campaign that included economic and technical assistance as well as equipment. Ultimately, the United States funded 80% of the costs of the French Indochina War.

In spite of the infusion of American firepower, France lost. Admitting defeat to the Viet Minh at the remote highlands village of Dien Bien Phu in 1954, France agreed to exit the country by terms to be negotiated at an international conference in Geneva, Switzerland.

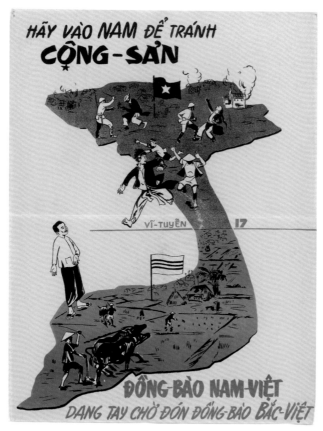

United States Information Agency poster, 1954.
National Archives at College Park, MD

Dividing Vietnam

Victory on the battlefield did not get the Viet Minh as much as they expected at the negotiating table. The Geneva Accords temporarily divided Vietnam midway at the 17th parallel, creating an anti-communist government in the south and a communist government in the north. Elections to reunify the country were to be held within two years, by mid-1956. This was not the outcome that Ho Chi Minh sought, but his Soviet and Chinese backers persuaded him to accede to American demands in order to forestall direct intervention by the United States.

The Accords allowed for a grace period of open travel between northern and southern zones. During this time, nearly one million people moved south. They were encouraged and assisted by the United States, but also prompted by conflicts and fear of reprisals in the north, including a brief but brutal campaign of land reform. American intelligence outfits produced propaganda such as this poster, which urged northerners to "go south to escape communism."

President Ngo Dinh Diem: South Vietnam

President Ngo Dinh Diem was a devout Catholic whose political philosophy blended Confucianism and Christian spiritualism. An opponent of French rule in Indochina, he sought to fashion a modern, anti-communist Republic of Vietnam, also known as South Vietnam. As part of his nation-building ambitions, Diem attempted to transform the countryside through large-scale resettlement of the rural population. He also cracked down harshly on those who disagreed with his development and security policies, igniting domestic and international criticism. Resistance to his regime mounted.

The Eisenhower administration sent Diem money and weapons, believing that a firmly anti-communist South Vietnam was necessary to its Cold War endeavors. Between 1955 and 1961, Diem's government was one of the largest recipients of American aid in the world. Eisenhower also backed Diem's decision not to participate in the Geneva-mandated elections.

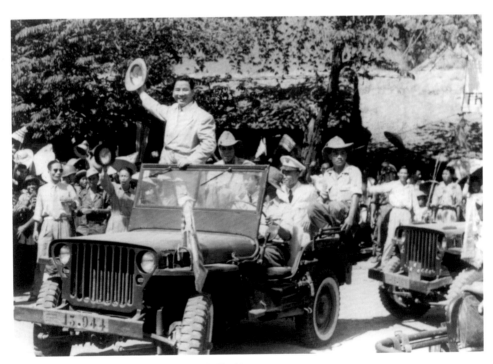

Ngo Dinh Diem visits Qui Nhon, May 1955. The Vietnam Center and Archive at Texas Tech University

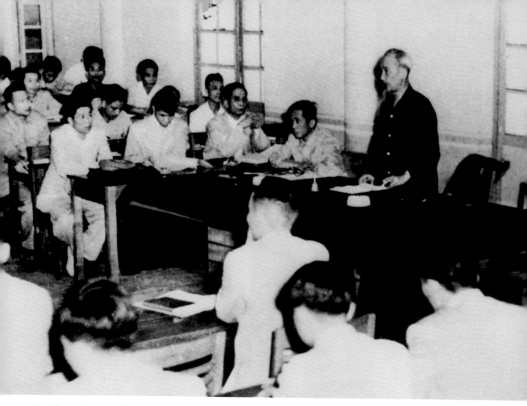

*Ho Chi Minh in conference with communist comrades,
1959. © Vietnam News Agency*

President Ho Chi Minh: North Vietnam

By the time the Viet Minh defeated France in 1954, Ho Chi Minh had been working for Vietnamese independence for decades. From the end of World War I until the late 1940s, he angled in vain for American support.

Ho admired communism for its forceful endorsement of anti-colonialism, and communism served as the revolution's ideological foundation. After the end of the French Indochina War, Ho presided over the government of the Democratic Republic of Vietnam, which was quickly becoming known as North Vietnam. He resolved to reunify the country.

In South Vietnam, Vietnamese who shared Ho's vision and had been part of the Viet Minh became targets of the Diem government. The regime's campaigns to quash dissent and maintain control included imprisonment and executions. Feeling themselves under siege, these southerners fought back and appealed to Ho and their northern compatriots for help. In Hanoi, at the meeting shown in this photo, Ho and other revolutionary leaders pledged political and military support for an armed insurrection in South Vietnam.

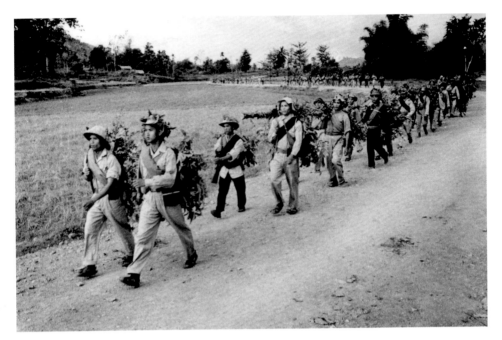

A National Liberation Front unit on the move.
© Vietnam News Agency

An Insurgency in South Vietnam

In 1960, Diem's opponents in South Vietnam, acting at the direction of the Hanoi government, formed the National Liberation Front (NLF). They were united by a desire to replace the Diem regime with a coalition government that better represented the South's population, willingness to open up dialogue with the North, and dislike for the United States' growing influence on Vietnamese affairs. Diem derisively labeled NLF members "Viet Cong," the Vietnamese equivalent of "commie." The term stuck.

The NLF's political arm set out to win the loyalty of the South Vietnamese population. Its military arm deployed a guerilla force of regular and irregular troops, under the command of southern communists. North Vietnam provided overall leadership and, increasingly, soldiers. Now the conflict was both a civil war within South Vietnam and a fight about reunifying the two Vietnams.

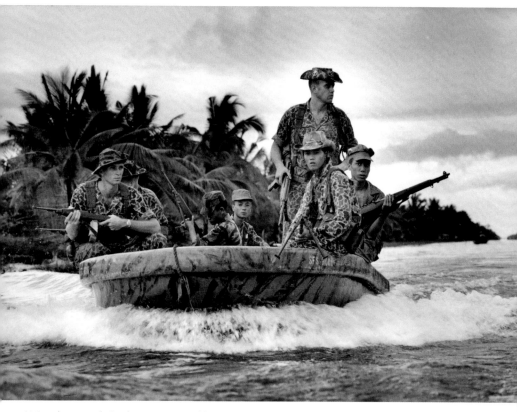

U.S. advisers with South Vietnamese soldiers, 1963.
James Karales / Estate of James Karales

President Kennedy Sends Military Advisers

As President John F. Kennedy took office, Diem continued to struggle to maintain control of South Vietnam. Kennedy ruled out committing U.S. troops to the effort. However, in 1962, his administration began providing Diem and his Army of the Republic of Vietnam (ARVN) with vast quantities of military aid, including fighter jets, helicopters, and armored personnel carriers, to assist in the escalating fight against the NLF's army.

In addition, Kennedy increased the number of U.S. military advisers in-country to nearly sixteen thousand. This included members of the elite Special Forces units known as the Green Berets. They trained ARVN troops, assisted the Diem government in moving the rural population into defensive "strategic hamlets," and accompanied South Vietnamese forces on combat missions. American helicopter crews also transported ARVN troops around the country.

Civil Unrest and the Buddhist Crisis

Buddhist monk Thich Quang Duc set himself on fire on a busy Saigon street in June 1963 to protest the Diem regime's treatment of Buddhists. Photographer Malcolm Browne managed to capture this image, having been alerted by monks that something important was about to happen. This shocking act of defiance emerged from and galvanized a wave of Buddhist-led protests that exerted considerable sway among the majority Buddhist population. It also amplified growing apprehension about Diem among his American supporters.

In November 1963, this spiraling civil unrest in South Vietnam culminated in a U.S.-approved coup. South Vietnamese military officers killed Ngo Dinh Diem and installed one of their own. Just weeks later President Kennedy was assassinated in Dallas, and Vice President Lyndon Johnson assumed office. South Vietnam's uneasy future was passed to a new set of leaders.

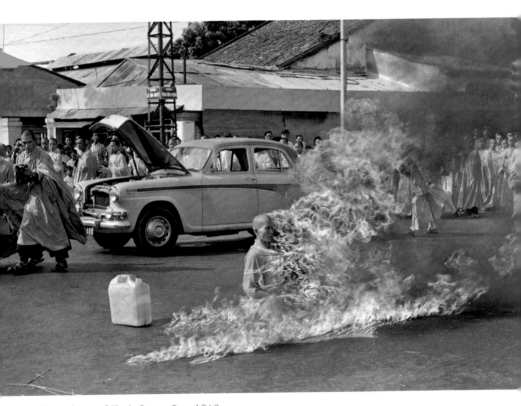

Self-immolation of Thich Quang Duc, 1963.
Malcolm Browne / Associated Press

Waging Wider War: The Gulf of Tonkin

In early August 1964, the American naval destroyers *Maddox* and *Turner Joy* were conducting secret surveillance operations in the Gulf of Tonkin in North Vietnam in tandem with South Vietnamese commando raids. In two separate incidents, those aboard the destroyers reported receiving fire from North Vietnamese torpedo boats. The details were far from clear and there was some doubt that the attack involving the *Turner Joy* occurred at all.

President Johnson and his staff decided on an immediate military response, sending U.S. aircraft to bomb North Vietnamese targets. Secretary of Defense Robert McNamara and others characterized the North Vietnamese

actions as unprovoked acts of violent aggression, and urged Congress to authorize the use of military force in Vietnam.

Acting under intense pressure and with limited information, Congress passed the Gulf of Tonkin Resolution. It granted the president broad powers to wage a wider war and allowed him "to take all necessary steps, including the use of armed force" to defend South Vietnam's government. Two senators dissented; one of them, Oregon Democrat Wayne Morse, challenged the administration, stating, "I believe this resolution to be a historic mistake."

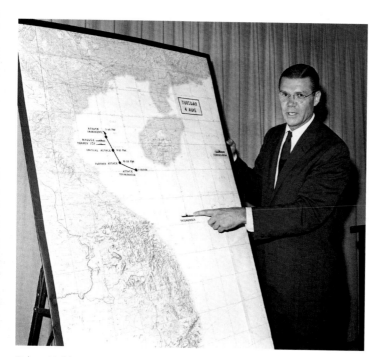

Robert McNamara points to the Gulf of Tonkin, August 4, 1964. Bob Schutz / Associated Press

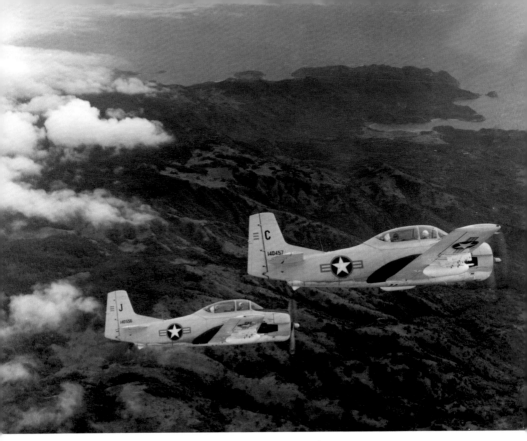

Vietnamese Air Force pilots fly U.S.-built T-28C Trojans over South Vietnam, 1962. Photograph, Robert Lawson / Courtesy of the National Museum of the Air Force ®

The War in the Air

In several confrontations at the end of 1964, NLF fighting forces inflicted significant damage on ARVN troops. The NLF's success demonstrated their growing military strength and influence, and deepened concern about ARVN's capabilities. Fearful about the future of South Vietnam, Johnson and his advisers opted for more decisive action.

An NLF attack on a U.S. helicopter base in Pleiku in early 1965 prompted American retaliatory air raids on North Vietnam. The raids developed into an extended bombing campaign against North Vietnam, dubbed Operation Rolling Thunder, which aimed to convince Hanoi to stop its support for the southern insurgency.

Even before Rolling Thunder, South Vietnamese and U.S. forces had already been conducting air operations in South Vietnam and Laos. This ongoing campaign involved extensive bombardment and the spreading of chemical defoliants like Agent Orange to clear jungle and aid military operations.

SDS and the Antiwar Movement

Antiwar activists in Students for a Democratic Society (SDS) created this poster using a photo of a child burned by napalm to argue that U.S. policy in Vietnam was immoral and anti-democratic. The sign was carried at an SDS-sponsored rally in Washington, D.C., on April 17, 1965. Twenty thousand people attended. It was the first major anti-Vietnam war protest and surprised even the organizers with its size.

SDS was a leading national organization for college student activists. Founded at the University of Michigan in 1962, it addressed a broad range of issues, including civil rights, economic inequality, and nuclear arms proliferation. As the war escalated, however, Vietnam came to dominate its activities. Hoping that an informed public would organize against the war, SDS sponsored "teach-ins" filled with discussion and debate on campuses nationwide in the spring of 1965.

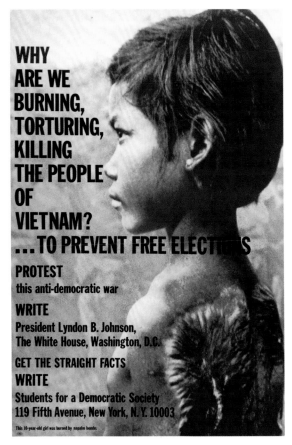

Students for a Democratic Society poster, 1965. New-York Historical Society Library

Sending Americans into Combat

United States Marines landed in South Vietnam in March 1965. They were charged with defending American air bases active in bombing operations. Their role rapidly shifted to ground combat as the military situation worsened. In July of that year, President Johnson announced a major increase in troop levels and a doubling of the draft. By the end of the summer, more than 125,000 American servicemen were in-country.

For the millions of young men subject to President Johnson's call to arms, the draft presented personal and political challenges: Should I volunteer? Wait to be drafted? Try to avoid or resist? One young man later recalled, "I looked at it as something I just had to do. I knew it was coming ... Like a freight train that was going to involve me sooner or later."

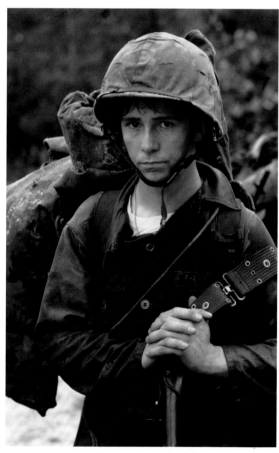

Young Marine landing at Danang, 1965.
National Archives at College Park, MD

Draft card, 1960. Courtesy of Joseph Corrigan,
C Troop, 2/1 Cavalry Regiment, 4th Infantry
Division, Dak To, Vietnam, 1967–68

The Draft

The Selective Service System required all men between the ages of 18 and 25 to register for the draft. But the pool of eligible baby boomers was larger than was needed, even during wartime escalation. So the Selective Service used a system of classifications and deferments to call up the men needed while minimizing the societal impact of the draft.

Deferments were available to full-time college students, men in key civilian occupations, ministers, conscientious objectors, and other designated categories. Men from middle- and upper-class families were better able to take advantage of deferment opportunities, leading to class inequities that persisted throughout the war. A disproportionately high rate of casualties among racial minorities in the early years was reduced after significant public protest achieved a change in military policy.

Over the course of the war, nearly 27 million American men came of draft age; 2.7 million were sent to Vietnam.

Deployment

In the war's early years, American servicemen traveled to Vietnam aboard troopships like the *General Nelson M. Walker*. On each of its trips, the *Walker* carried nearly five thousand troops on a three-week voyage. To pass the time on the long journey, men played cards and games, listened to music provided by the ship's crew, wrote letters, and watched movies.

Marines and GIs slept on berthing units that held six to eight men, and many wrote and drew on the canvas bunks directly above them. Their graffiti reflected all the anxiety and excitement of men heading to war. "They wanted to leave a little piece of them, a little piece of their heart, a little piece of their soul behind," army veteran Jerry Barker later explained. Barker was twenty years old when he traveled to Vietnam aboard the *Walker*.

The United States stopped transporting troops by ship in 1968, instead using airplanes to send replacement troops. Years later, in 1997, the Vietnam Graffiti Project rescued bunks and canvases from the *Walker* to preserve this piece of history. These artifacts survive as a telling record of young men's hopes and fears as they headed to an uncertain fate in Vietnam.

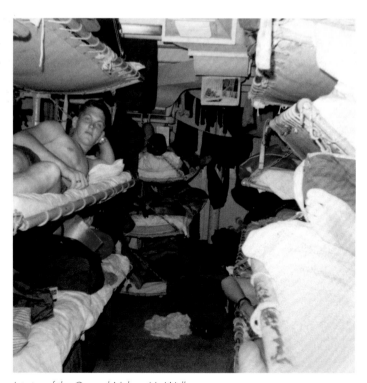

Interior of the General Nelson M. Walker.

Canvas with graffiti by Zeb Armstrong to his wife, Billie.
Courtesy of Art & Lee Beltrone, Vietnam Graffiti Project, Keswick, VA

337th
Signal Co.

Connie

Suleborn N. C.

William Rosewood N. C.

Myers

Fra...

Black
Cafe

Billie Armstrong
My dear Wife

Zeb Armstrong
~~Zeb Armstrong~~
Clover S.C.
E.T.S. 69
8/16/ 67 Viet Nam
Bound

Will
I
Return???

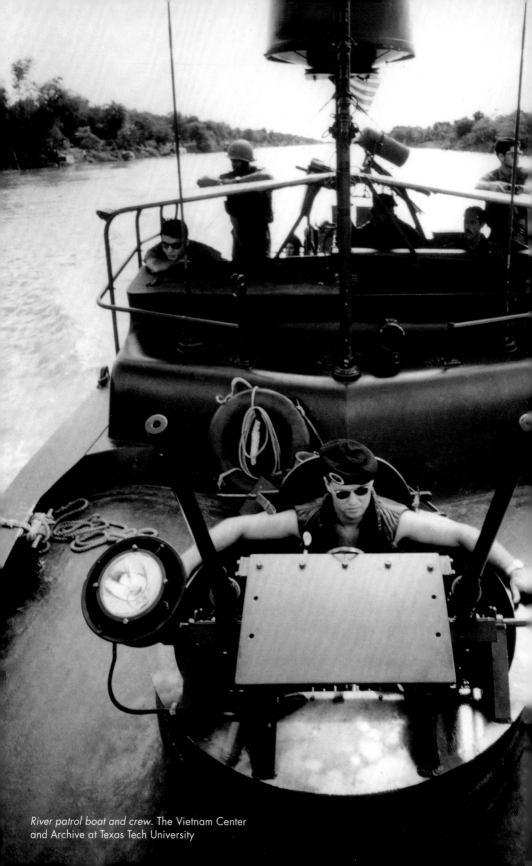

*River patrol boat and crew. The Vietnam Center
and Archive at Texas Tech University*

WAR ON MANY FRONTS 1966– 1967

Let me say finally that I oppose the war in Vietnam ecause I love America. I speak out against it not in nger but with anxiety and sorrow in my heart, and bove all with a passionate desire to see our beloved ountry stand as the moral example of the world."

Dr. Martin Luther King Jr., February 25, 1967

e decision by American leaders to commit the country to war attracted pular support as well as a groundswell of criticism. It also required it the U.S. achieve victory on a complex battlefield in a nation where ishing visions of the future divided the population's loyalties.

The main theater of war was South Vietnam. On one side, the ite of combatants included the U.S. military and the armed forces of uth Vietnam (collectively referred to as ARVN). They were assisted by all numbers of Australians and New Zealanders, and, with economic ncessions, larger numbers from places such as South Korea.

Their opponents hailed from both South and North Vietnam. e South Vietnamese were organized into the National Liberation ont (NLF), which the American side called the Viet Cong. North etnamese who came south to fight did so as part of the People's my of Vietnam (PAVN), also known as the North Vietnamese Army VA). They received logistical support and weaponry from China and e Soviet Union.

American troops landing in-country faced a harsh natural vironment and a fiercely determined enemy. Unconventional tactics acticed by the NLF and PAVN challenged a U.S. military trained more traditional warfare. Despite a clear superiority in technology d material resources, American forces were unable to achieve a ick victory against an enemy who could hide in remote mountains d jungles as well as in neighboring Laos and Cambodia. The United ites began digging in for the long haul, building ports and bases all er South Vietnam.

President Lyndon B. Johnson had decided not to invade North etnam, believing this would risk war with China, Vietnam's ighbor to the north. So American military commanders pursued eir war of attrition inside South Vietnam. Their strategy relied avily on the first widespread deployment of helicopters in war. S. Huey and Chinook helicopters dropped troops and supplies into rrowing terrain throughout South Vietnam and removed their dead d wounded.

As the French had experienced, this was a war without lines. It is often extremely difficult to tell friend from foe. While ARVN sought reassert control over the rural population, U.S. troops engaged in

"search and destroy" missions aimed at locating and killing the enemy. "Body count" became a standard measure of success.

As the war intensified, military and civilian casualties rose dramatically. Communist forces maintained their troop strength by infiltrating replacements from North Vietnam. U.S force numbers also swelled, but there was little sign that American efforts were making a dent in the enemy's ability to continue fighting.

On the home front, opinion about the war was becoming increasingly divided. While journalists reported on U.S. military victories and individual acts of heroism, they also captured agonizing images of burning villages, refugees, and heartrending casualties. Prominent public figures, including Senator J. William Fulbright and Dr. Martin Luther King Jr., began to publicly challenge the war's wisdom and justice. An antiwar movement originating in churches and on college campuses grew to include a wider portion of the American public. Through teach-ins, debates, and demonstrations, opponents of the war offered a central message: the Vietnam War was wrong and must end.

Despite the growth of antiwar activity, the majority of Americans still supported the war effort. Many of these Americans were alarmed by raucous antiwar demonstrations and other signs of unrest, seeing them as symptoms of a larger societal breakdown. Socially and politically, the war divided Americans and sparked debates that touched on some of the most important elements of American democracy, from dissent and patriotism to the responsibilities of citizenship and the nature of the United States' role in the world.

These deepening divisions affected the White House as well. When addressing the American public, President Johnson stood behind his decisions and insisted the war was under control. In private, though, he and his staff had doubts and disagreements. Johnson and his team decided to meet their critics head on with a late-1967 media blitz, assuring the public that victory was just around the corner. The plan for achieving this victory, however, remained unclear.

By the end of 1967, more than twenty thousand American troops had died in Vietnam. Public outcry for decisive action— whether it be for more peace or more war— was impossible to ignore. The Vietnam War had become an American crisis.

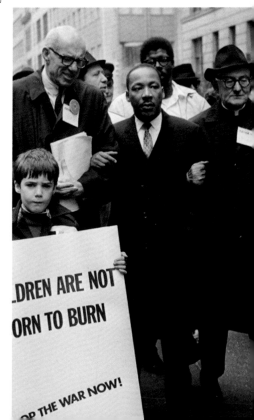

Dr. Martin Luther King Jr., see page 51

DREN ARE NOT
ORN TO BURN
OP THE WAR NOW!

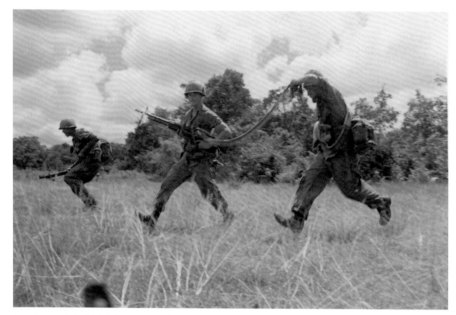

Members of the 16th Infantry, 1st Infantry Division, advance under sniper fire during a search and destroy mission, 1965. Photograph, Allan K. Holm / National Archives at College Park, MD

U.S. and ARVN Forces

American combat troops in Vietnam confronted a punishing physical terrain, extreme heat and humidity, and a hidden enemy seemingly capable of mounting attacks at any place and time. A serviceman's year-long tour of duty fluctuated between boredom, exhaustion, and terror.

Vietnam veteran and writer Philip Caputo explained in his memoir *A Rumor of War* (1977), "The war was mostly a matter of enduring weeks of expectant waiting and, at random intervals, of conducting vicious manhunts through jungles and swamps where snipers harassed us constantly and booby traps cut us down one by one ... usually followed by more of the same hot walking, with the mud sucking at our boots and the sun thudding against our helmets."

The U.S. Army, Marines, Navy, Air Force, and Coast Guard all conducted operations in South Vietnam. Between 1964 and 1968, U.S. troop levels there expanded from 16,000 to more than 500,000. For every person in combat, many others served in a variety of support positions, including engineering battalions, clerks, and communications specialists.

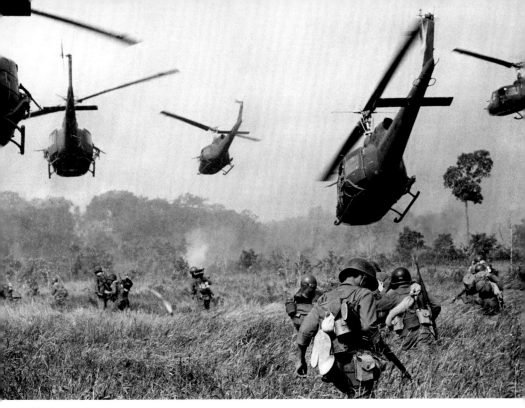

U.S. Army helicopters cover the advance of ARVN troops, 1965.
Horst Faas / Associated Press

The Republic of Vietnam Armed Forces included the Army, Air Force, Navy, Airborne Division, Marines, Rangers, Regional and Popular Forces, Civil Defense Forces, and Women's Armed Forces Corps. To most Americans, however, the South Vietnamese military was known collectively as ARVN, the acronym for the army.

Between 1965 and 1968, South Vietnamese troops worked largely on strategic campaigns meant to end the enemy's control of the countryside, while also joining Americans on search and destroy missions. Plagued by structural and political problems, ARVN gained a reputation among many Americans as an ineffective fighting force, even if some units performed well.

By the end of 1968, one in six South Vietnamese men served in the military, often drafted for years at a time and sustaining heavy casualties. "You lived together and protected each other, and died together so to speak," recalled a military doctor in the Rangers. "The bond glued the soldiers and the officers on the front line ... That bond has stayed with me until now."

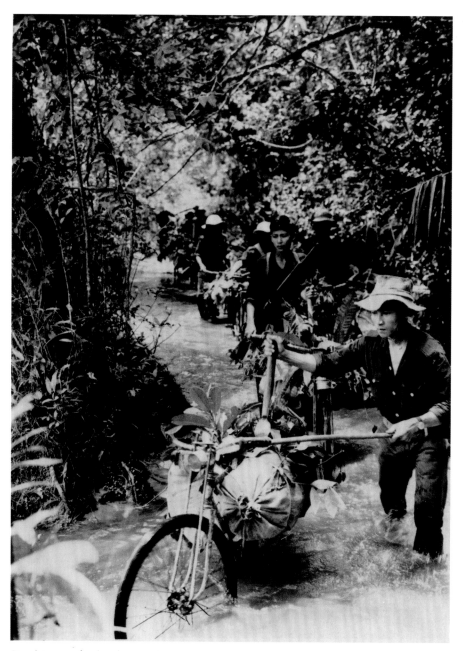

Bicyclists carry food and ammunition down the Ho Chi Minh Trail, 1966. Dinh Thuy / © Vietnam News Agency

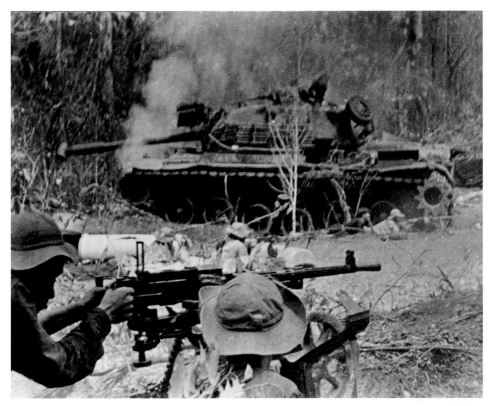

National Liberation Front forces during the Battle of Dong Rum, 1967. © Vietnam News Agency

NLF and PAVN Forces

U.S. and ARVN forces were opposed by both South and North Vietnamese troops. The NLF recruited regular and irregular fighters from the South Vietnamese population. Conventional PAVN troops traveled from North Vietnam down the Ho Chi Minh Trail— an elaborate transportation system built under Hanoi's direction beginning in 1959. As the war progressed, the trail evolved into an intricate system of dirt roads, army barracks, hospitals, supply bunkers, storage areas, and command and control centers. Passing through Laos and Cambodia, it brought crucial manpower and supplies, including food and ammunition, into South Vietnam.

The NLF and PAVN sought to endure the onslaught of superior American firepower by choosing when and where to fight. Large battles were rare. More often, relatively small groups of soldiers conducted raids, ambushes, sabotage, and other acts of guerilla warfare. Fighters capitalized on their knowledge of the terrain and ability to blend in with the local population. The construction of elaborate networks of bunkers and tunnels allowed them to hide by day and fight by night.

45

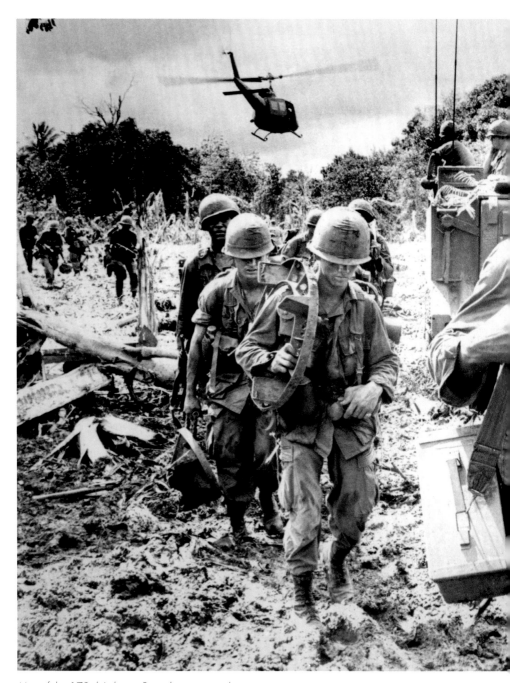

*Men of the 173rd Airborne Brigade on a search
and destroy patrol after receiving supplies, 1966.*
National Archives at College Park, MD

U.S. Military Strategy

Facing a determined and well-organized enemy, the American and South Vietnamese forces developed a two-pronged strategy to wear down the NLF insurgents and their North Vietnamese allies.

The primary mission of U.S. forces was to destroy the enemy and their logistical network. American ground troops operated throughout South Vietnam, supported by naval and air campaigns. They defended the Demilitarized Zone to prevent a North Vietnamese invasion, fought the enemy in the remote Central Highlands to block cross-border infiltration, pursued units in the hills along the Central Coast, combed through NLF base areas in the Iron Triangle on the periphery of Saigon, and ranged across the upper Mekong Delta as part of an Army-Navy mobile riverine force.

South Vietnamese forces focused on pacifying the countryside. They targeted local NLF units and tried to improve security, develop the economy, and extend the government's control. In practice, the "search and destroy" war overlapped with the "pacification" war. American and South Vietnamese forces often worked together to defend densely-populated areas and mount large-scale search and destroy missions.

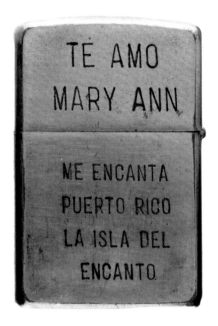

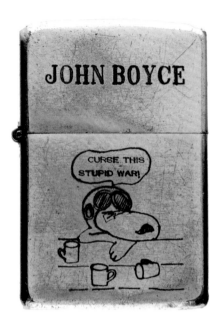

The Things They Carried

Most U.S. military personnel in Vietnam carried Zippo lighters. Zippos lit cigarettes, illuminated dark spaces, and were even traded as a form of currency. For those who carried them, the lighters also served as blank canvases. Engraving messages and images was a popular practice, with many troops choosing antiwar mottos, religious verses, political slogans, and combat slang. Zippos also became symbols of American destruction. In 1965, CBS aired a report featuring footage of Americans engaged in a search and destroy mission using their lighters to burn down the grass huts of a South Vietnamese village.

Of course, Americans in Vietnam carried much more than just lighters. Although the number and type of items varied, most combat GIs took on a load ranging from 60 to 100 pounds. What made up all this weight? In addition to clothing and fighting equipment—jungle boots, helmet, weapons, and ammunition—they also carried food, water, and items for personal and

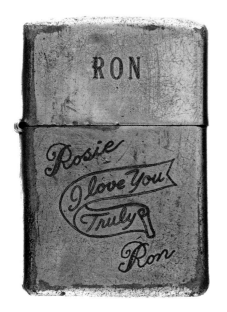
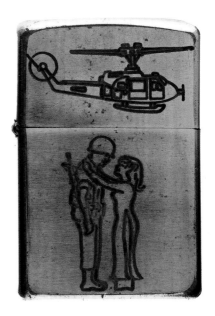

Zippo lighters. New-York Historical Society, Gift of John R. Monsky. Photography, Glenn Castellano

physical comfort. These included books, letters from home, can openers, pocket knives, cigarettes, mosquito repellent, and more.

The idea of carrying weight (or "humping," in GI slang) became a powerful symbol, standing in for the soldier's burden of carrying the war itself. In *The Things They Carried* (1990), a fictionalized version of his combat experience, author and Vietnam veteran Tim O'Brien explains, "for all the ambiguities of Vietnam, all the mysteries and unknowns, there was at least the single abiding certainty that they would never be at a loss of things to carry".

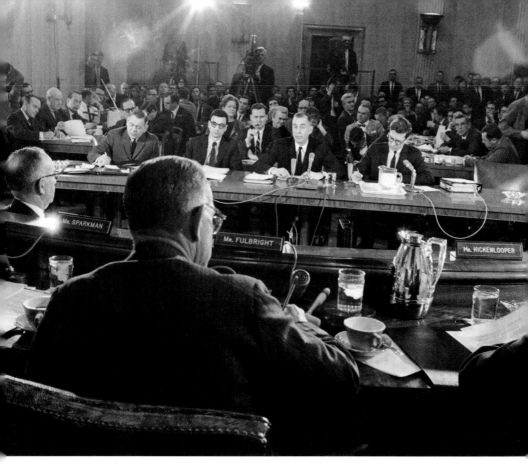

Senate Foreign Relations Committee hearings on the war in Vietnam, 1966. U.S. Senate Historical Office

Congress Questions the War

In the early months of 1966, Senator Fulbright led a series of nationally televised congressional hearings on the Vietnam War. Millions of Americans were riveted as members of President Johnson's administration, including Secretary of State Dean Rusk and General Maxwell Taylor, answered days of questioning about the war's logic, planning, and progress.

A widely respected member of Congress and the chair of the Senate Foreign Relations Committee, Fulbright had played a key role in passing the 1964 Gulf of Tonkin Resolution authorizing the use of force in Vietnam. However, when the war expanded, he insisted that Congress, like the American people, had been misled, and had not foreseen that the resolution would be used to justify a large-scale war in Asia.

In his book *The Arrogance of Power* (1966), Fulbright defended his criticism, saying, "It is a service because it may spur the country to do better than it is doing; it is a compliment because it evidences a belief that the country can do better than it is doing."

"Beyond Vietnam," MLK Jr.

Respected civil rights leader Dr. Martin Luther King Jr. felt a duty to speak out against the Vietnam War. Despite private concerns about its reception, on April 4, 1967, King delivered a speech against the war at Riverside Church in New York City. "Beyond Vietnam: A Time to Break Silence" was a deeply personal statement that expressed moral outrage at the war's destruction.

King also lamented how the war had come to take precedence over Johnson's Great Society programs: "It seemed as if there was a real promise of hope for the poor—both black and white—through the poverty program...

Then came the buildup in Vietnam, and I watched this program broken and eviscerated as if it were some idle political plaything of a society gone mad on war."

Many prominent newspapers, including the *New York Times* and the *Washington Post*, condemned King's stand. While controversial, "Beyond Vietnam" resonated profoundly with many Americans who found King's arguments ethically and politically persuasive.

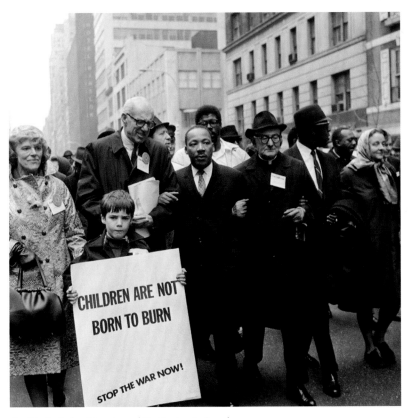

Dr. Martin Luther King Jr. and Dr. Benjamin Spock walk with the Spring Mobilization march in New York City, 1967. AFP / Getty Images

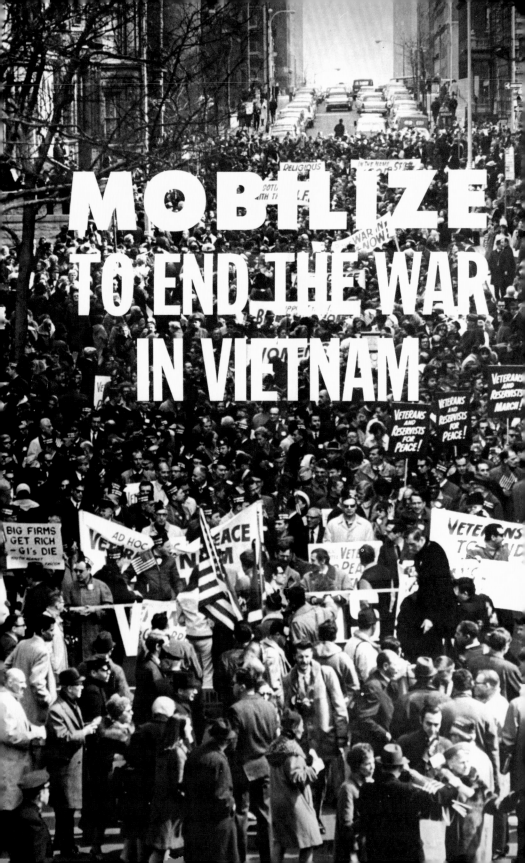

APRIL 15

ASSEMBLE

11:00 a.m.

CENTRAL

PARK

SHEEP

MEADOW

(66th St.)

WALK TO

U.N. RALLY

3:00 p.m.

SPRING MOBILIZATION COMMITTEE
TO END THE WAR IN VIETNAM

A. J. MUSTE, Founding Chairman
REV. JAMES BEVEL, National Director

857 BROADWAY
NEW YORK, N. Y. 10003
Phone: 212 - 675 - 4605

Spring Mobilization to End the War

Massive crowds gathered in New York and San Francisco on April 15, 1967, to express public opposition to the Vietnam War. Known as the Spring Mobilization to End the War in Vietnam, the demonstrations were organized by prominent civil rights and antiwar activists. Supporters included Dr. King, celebrated pediatrician and author Dr. Benjamin Spock, and longtime labor organizer and pacifist leader A. J. Muste.

While thousands of Americans had been participating in teach-ins and other antiwar protests since 1965, the Spring Mobilization was the largest demonstration against the Vietnam War the country had yet witnessed. It attracted hundreds of thousands of participants, from church and religious groups to labor unions and professional organizations.

Carrying signs with slogans like "Stop the Bombing," "Wipe Out Poverty Not People," "Support Our GIs—Bring Them Home Now," "Black Men Should Fight White Racism," and "Children are Not Born to Burn," protestors connected issues of civil rights, poverty, and democracy to their stand against the war.

Mobilize to End the War in Vietnam poster, 1967. Swarthmore College Peace Collection 53

Support Our Men in Vietnam poster, 1967.
New-York Historical Society Library

Support Our Men

With antiwar protests capturing the media's attention, Americans who supported the war felt their voices were being marginalized. On May 13, 1967, the American Legion helped organize the "Support Our Men" parade along Fifth Avenue in New York City. The New York Fire and Police Departments, unions such as the International Longshoreman's Association, and advocacy groups such as Young Americans for Freedom all participated. Attracting an estimated seventy thousand marchers and lasting over eight hours, the parade was the largest pro-war event of the Vietnam era.

The parade reflected a visceral anger towards the antiwar movement. The organizers used a photo from the antiwar Spring Mobilization march as a rallying cry. And along the parade route, violence between pro- and antiwar demonstrators broke out at several points, reflecting growing divisions among Americans.

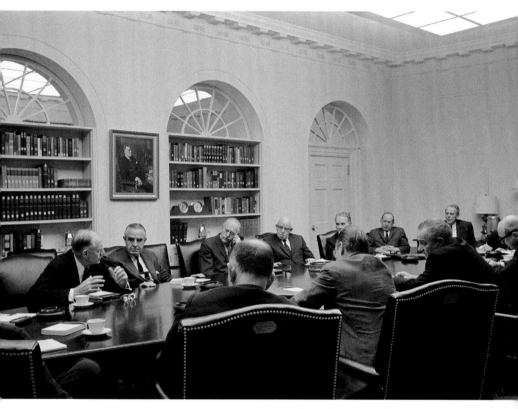

President Lyndon Johnson meets with foreign policy advisers, November 1967. LBJ Library Photo by Yoichi Okamoto

The Wise Men

Hoping to find a way forward in Vietnam, President Johnson met with some of his most trusted foreign policy advisers in November 1967. The group, known informally as the Wise Men, included former Secretary of State Dean Acheson, national security adviser McGeorge Bundy, and General Maxwell Taylor, among others. At this meeting, they expressed confidence in the overall direction of the war, but acknowledged that it had become a difficult political issue.

The Wise Men advised the administration to engage in a more aggressive and optimistic media campaign to convince the American public of the war's necessity and progress. In response, General William Westmoreland, head of U.S. forces in Vietnam, and other officials accelerated their publicity efforts, insisting in a series of high-profile appearances that an American victory was just around the corner.

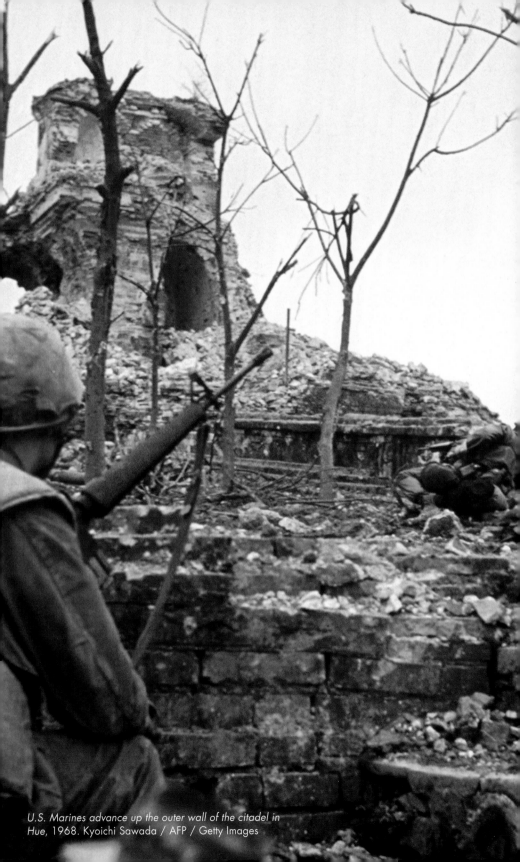

U.S. Marines advance up the outer wall of the citadel in Hue, 1968. Kyoichi Sawada / AFP / Getty Images

TURNING POINT 1968

"We have been too often disappointed by the optimism of the American leaders, both in Vietnam and Washington, to have faith any longer in the silver linings they find in the darkest clouds ... For it seems now more certain than ever that the bloody experience of Vietnam is to end in a stalemate."

– Walter Cronkite, CBS Evening News, February 27, 1968

Often remembered as the peak year of a turbulent decade, 1968 brought America's social, political, and racial tensions boiling to the surface. The Vietnam War was central to these developments, driving a series of events that brought the war and its fallout to the forefront of the national agenda.

American policymakers, including President Johnson and General Westmoreland, spent the latter months of 1967 reassuring Americans that their war strategy was working, the enemy was weakening, and the end was in sight. During this same time, the North Vietnamese government was making plans for a series of coordinated attacks in South Vietnam to be spearheaded by the National Liberation Front. The offensive aimed to weaken or destroy the South Vietnamese military and government by inciting a popular uprising. It would be timed to coincide with Tet, the Vietnamese New Year holiday.

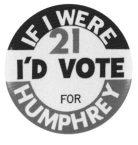

Hubert Humphrey campaign button, 1968. Minnesota Historical Society

On January 31, 1968, PAVN and the NLF launched strikes on more than 100 cities and towns in South Vietnam during the Tet ceasefire. The surprise attacks focused on key military and civilian targets. In the capital city of Saigon, enemy soldiers even briefly breached the walls of the American Embassy. American and South Vietnamese forces were initially stunned by the timing and strength of the onslaught. But they quickly regrouped to repel the attacks. The toll on both civilians and combatants was enormous. Tens of thousands were injured or killed, including so many NLF fighters that their role in subsequent battles fell substantially, to be replaced by PAVN troops. Well over 600,000 South Vietnamese were made homeless. The Tet Offensive did not achieve its military objectives, but it still had a dramatic impact on the direction of the war.

American television viewers were suddenly confronted by images of carnage and chaos that seemingly contradicted the optimistic forecasts of the Johnson administration. The enemy's unexpected show of strength reinforced the steadily growing sense that the war was fundamentally unwinnable, a lost cause.

For U.S. leaders in charge of war policy, Tet's fallout was considerable. General Westmoreland was reassigned to Army Chief of Staff, having lost his bid to massively expand the war when the new Secretary of Defense, Clark Clifford, argued that more troops would not assure military success. And in a televised speech that stunned the nation, President Johnson announced that he would not seek re-election in November. He also called for "serious talks on the substance of peace," and ordered a partial halt to the bombardment of North Vietnam. Johnson acknowledged the tumult then gripping American society and warned the nation to "guard against divisiveness and all its ugly consequences."

The spring of 1968 brought more shocking events. The assassinations of civil rights leader Martin Luther King Jr. on April 4 and antiwar Democratic presidential candidate Robert F. Kennedy on June 6 created visceral outrage and despair. In the wake of Dr. King's murder, civil unrest broke out in cities across the nation, underscoring the persisting problems of urban poverty and pervasive racism. The riots also convinced growing numbers of Americans that disorder and lawlessness had reached intolerable levels. With a presidential election looming in November, American society was consumed by fierce divisions over race, the war, and the troubling direction of the nation.

The Democratic Party, seeking a candidate to replace Lyndon Johnson, endured a turbulent primary battle that exposed bitter disagreements over the war. In August, the party held its convention in Chicago. Vice President Hubert Humphrey, who was favored by moderate and conservative Democrats and identified with Johnson's stance on the war, secured the nomination. Outside the convention hall, thousands of antiwar activists demonstrated against these very policies. Television cameras caught scenes of violence and chaos, as police and National Guard forces attacked protestors and others. Protestors chanted "the whole world is watching."

Sensing the public's weariness and the Democratic Party's weakness, Republican nominee Richard Nixon promised to restore law and order to a fractured American society. Highlighting his foreign policy experience, he also pledged to bring an honorable end to the war in Vietnam. In November 1968, Nixon won the presidency. A new administration set out to take control of one of the nation's most divisive wars.

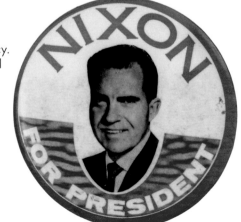

Richard Nixon campaign button, 1968.
New-York Historical Society

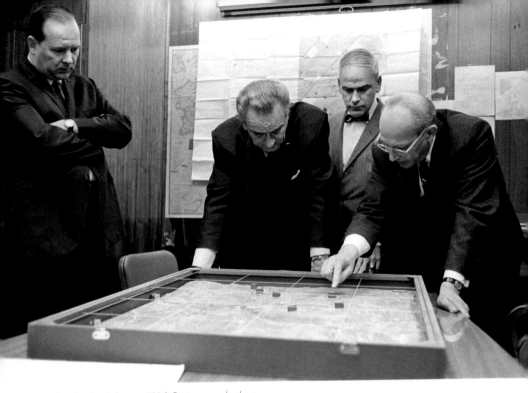

President Lyndon Johnson, Walt Rostow, and others look at relief map of Khe Sanh in the White House basement situation room, 1968. LBJ Library Photo by Yoichi Okamoto

The Siege of Khe Sanh

In January 1968, tens of thousands of North Vietnamese troops laid siege to Khe Sanh. This remote Marine base had been strategically located near the border with North Vietnam to halt enemy infiltration into southern territory. U.S. and ARVN troops were surrounded and under constant shelling. A member of the Special Forces recalled, "They'd have eleven hundred rounds come in in one 24 hour period. It was like the Second and the First World War all rolled up into one."

Cut off from ground support, they relied on massive retaliatory bombing and airlifted supplies and replacement troops to survive the onslaught. "You'd hear them shooting and you knew you had three to five seconds," one Marine explained. "You ran wherever you went. They called it the 'Khe Sanh Shuffle.'"

President Johnson, wary of the parallels being drawn to the French defeat at Dien Bien Phu, pressured his commanders to deliver a victory. Hanoi's military strategists hoped the siege would divert attention and resources from South Vietnam's cities, which they secretly planned to target in the coming Tet Offensive.

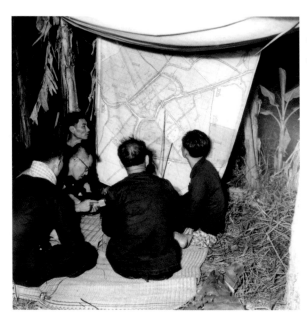

Guerillas in the Mekong Delta prepare for the Tet Offensive, 1968. Vo Anh Khanh / © Vietnam News Agency

The Tet Offensive

Hoping to turn the tide of the war, North Vietnamese leaders unleashed a major offensive that aimed to incite a national uprising and topple the South Vietnamese government and military. In the early morning hours of January 31, 1968, the NLF and PAVN launched surprise attacks on more than 100 South Vietnamese cities and towns. Firing rockets and mortars and engaging in fierce gun battles, they brought the fight directly into urban areas for the first time. Regrouping, U.S. and ARVN troops counterattacked, within days reversing most of the enemy's advances.

The contest had devastating effects on the country's infrastructure and civilian population. Speaking of the recapture of Ben Tre, a provincial capital in the Mekong Delta, a U.S. commander told reporter Peter Arnett, "It became necessary to destroy the town in order to save it."

Fighting in the ancient city of Hue was particularly destructive. NLF and

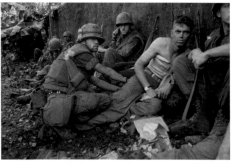

Treating wounded Marines during Operation Hue City, 1968. National Archives at College Park, MD

PAVN forces overtook the city. Block-by-block combat ensued, with U.S. and ARVN troops finally winning the city back after twenty-six days. By then, most of the buildings had been destroyed and much of the population made homeless. During the occupation, up to several thousand residents were killed for collaborating with U.S. and South Vietnamese forces.

Treating the Casualties

Approximately ten thousand female volunteers served in the military as nurses in Vietnam—about half of them with the Army Nurse Corps. Often stationed at hospitals and field units close to the fighting, nurses faced great danger while providing a critical lifeline for seriously wounded soldiers and civilians. Helicopter dust-off crews, named for the dirt kicked up as the helicopters took off, transported the wounded to hospitals as safely and quickly as possible. Thanks in part to the speed with which patients could be treated, nearly twice as many survived as in the Korean War.

During the Tet Offensive, nurses and medical staff at the 71st Evacuation Hospital in Pleiku, shown here, treated hundreds of new casualties from Dak To, Kontum, and Hue.

In addition to their vital work during times of intense fighting, hospitals like the 71st also provided more routine medical care, such as malaria treatment and immunizations. Some nurses also used their off-duty time to provide medical services to local civilian populations through MEDCAP, the Medical Civic Action Program.

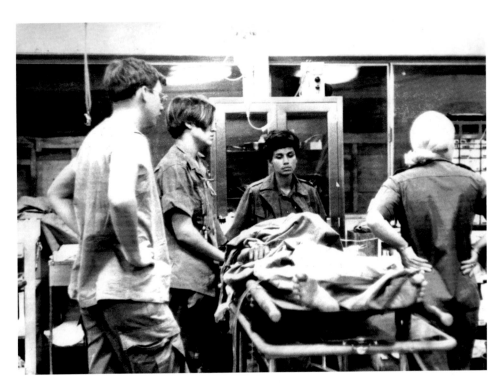

Nurses in the emergency triage area of the 71st Evacuation Hospital, Pleiku. From left to right: unidentified medical corpsman; 1st Lieutenant Lynne Morgan, ANC; 1st Lieutenant Marra Peche, ANC; and 1st Lieutenant Lynda Van Devanter, ANC.
Courtesy of Robb Ruyle

Walter Cronkite of CBS interviews Professor Mai,
University of Hue, 1968. National Archives at
College Park, MD

Reporting the War

The Vietnam War is often referred to as the "first television war" or the "first living room war," as unprecedented press coverage brought the conflict directly into American homes. More than in wars before or since, journalists in Vietnam operated free from government censorship and controls on their movement.

As the body count rose, and events like the Tet Offensive seemingly contradicted the optimistic official briefings, journalists increasingly filed reports whose views differed from those expressed by the U.S. military command. While some Americans felt that the news media was undermining the war effort, others felt it provided critical information and alternative perspectives.

In response to Tet, *CBS Evening News* anchorman Walter Cronkite, one of television's most trusted and influential journalists, traveled to Vietnam. After a week reporting from the field, he delivered a dramatic editorial concluding that the war was "mired in stalemate." With his signature straightforward style, Cronkite also warned that to further escalate the war by invading the North, using nuclear weapons, or deploying large numbers of additional troops would only bring the world "closer to the brink of cosmic disaster."

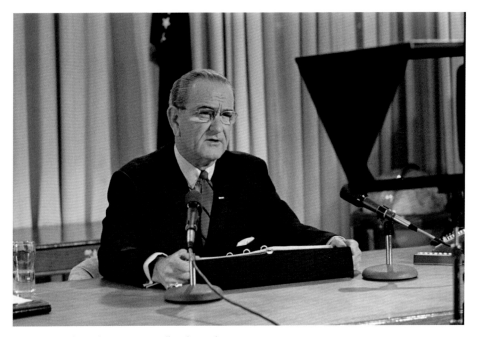

President Lyndon Johnson's nationally televised address on March 31, 1968. LBJ Library Photo by Yoichi Okamoto

Johnson Bows Out

Coming in an election year, the chaos and violence of the Tet Offensive created a political crisis for President Johnson and his administration. As shown by Walter Cronkite's stark conclusions, support for the war was waning and criticism becoming mainstream. Even some of Johnson's trusted advisers, whom the press called "the Wise Men," reversed their previous confidence in the administration's war policy. They advised against approving the massive new troop commitments requested by General Westmoreland, and suggested that the president consider how to negotiate withdrawal.

By the spring of 1968, Johnson faced significant challenges for re-election within his own party. Young people rallied to the campaigns of popular antiwar figures Senators Eugene McCarthy (D-MN) and Robert Kennedy (D-NY). They canvassed for their candidates even though those under twenty-one years old could not yet vote.* Citing the need for unity, Johnson announced on March 31 that he would not seek re-election that November.

———

*Advocacy to lower the voting age to 18 led to ratification of the 26th Amendment in 1971.

Democratic National Convention

By the time the Democrats held their convention in Chicago in August, their party was in turmoil. Popular candidate Robert Kennedy had been assassinated in June. The once-strong showing of antiwar candidate Eugene McCarthy had faltered. And Vice President Hubert Humphrey was saddled with the mantle of President Johnson's unpopular leadership on Vietnam.

Furious about the war, thousands of antiwar protesters descended upon the city in order to force the party to confront its Vietnam policies. Determined to thwart their aims, Mayor Richard Daley declared a zero-tolerance policy toward the demonstrators. Chicago police, Illinois state troopers, and the National Guard clashed violently with crowds in the city's streets and parks.

Inside the convention, the Vietnam plank dominated the debate. Hubert Humphrey emerged from the chaotic convention as the Democratic nominee.

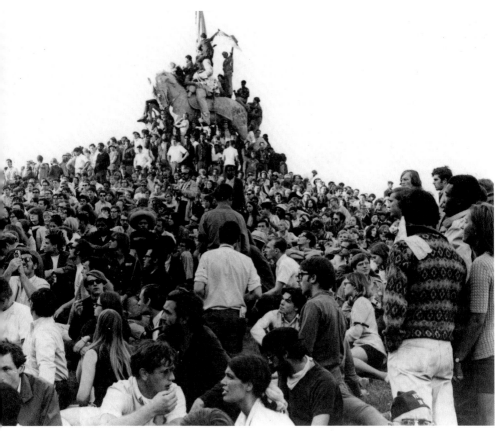

Protestors surround the General John A. Logan statue, Grant Park, 1968. Chicago History Museum IChi-50772; photo, Peter Bullock

1968 Election

In the general election, Democratic nominee Vice President Hubert Humphrey was opposed by Republican Richard Nixon, former vice president under Eisenhower, and Alabama Governor George Wallace, a fervent segregationist who ran as an Independent. All three candidates promised to improve on Johnson's record on the war.

In November, Nixon won the presidency by a slim margin in the popular vote but a substantial Electoral College majority. His campaign had focused on ending the draft, bringing the Vietnam War to an "honorable end," and restoring "law and order" to a bitterly divided nation.

Nixon's success among the traditionally minded Americans whom he later referred to as the "silent majority" reflected desire for a change in war policy as well as exhaustion with antiwar protests, urban riots, and countercultural lifestyles. In his victory speech, Nixon insisted that his administration's first major objective would be to "bring America together."

Hubert Humphrey and Richard Nixon campaign buttons, 1968. New-York Historical Society

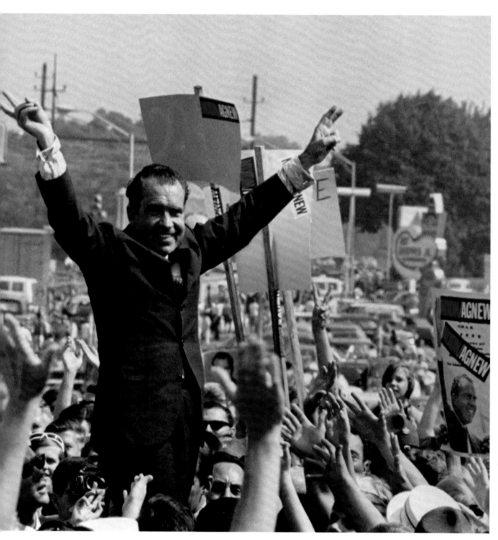

Richard Nixon on the campaign trail, 1968.
Oliver Atkins / George Mason University Special
Collections & Archives

October 9

VIETNAM VETS AGAINST THE WAR

STOP NIXON'S

Vietnam Veterans Against the War march in San
Francisco, 1972. Swarthmore College Peace Collection

ENDGAME
1969–1975

"And I pledge to you tonight that the first priority foreign policy objective of our next Administration will be to bring an honorable end to the war in Vietnam."

– Richard Nixon, August 8, 1968

Having promised American voters "peace with honor," President Nixon shifted the direction of U.S. military efforts in Vietnam. He hoped his administration could achieve what Johnson's had not. Nixon began withdrawing American troops and implementing his "Vietnamization" strategy, which slowly transferred the brunt of the ground fighting to South Vietnamese forces. At the same time, he expanded the air war and also secretly reopened negotiations.

Nixon's first months as president were marked by growing public discontent with the war, and in some quarters, fury. Millions of Americans skipped school and work in October 1969 to attend antiwar demonstrations held as part of a nationwide Vietnam Moratorium. In November, more than 500,000 people gathered on the National Mall in Washington, D.C., collectively singing John Lennon's "Give Peace a Chance."

Nixon responded directly to the Moratorium demonstrations, appearing on television to defend his Vietnam policies. In his "silent majority" speech, he insisted that dissent and division were barriers to his plan for peace and asked Americans to unite in support of his administration's strategies. Behind the scenes, the president's advisers convinced him to postpone a massive military campaign against North Vietnam, worried about inflaming antiwar sentiment.

Nixon's search for a bold military stroke continued nevertheless. On April 30, 1970, he announced that the U.S. would begin ground operations in Cambodia, attacking extensive enemy sanctuaries across the border. His decision came as a shock. It now seemed the president was expanding the war rather than winding it down.

The Cambodian campaign ignited a heightened round of antiwar activism. It also sparked a fierce response from those who opposed the protests. On May 4, 1970, during a rally at Ohio's Kent State University, National Guardsmen fired into a crowd of demonstrators and passersby, killing four and wounding nine. On May 8 in New York City, a demonstration memorializing the students killed at Kent State turned violent when groups of local construction workers attacked antiwar protestors in what became known as the Hard Hat Riot. And in Jackson, Mississippi, on May 14, two students were killed by police during turbulence sparked by anger over the war, race discrimination, and more. It felt to many Americans that the violence in Southeast Asia had come home.

Activism against the war was also growing bolder. In 1971, military analyst Daniel Ellsberg leaked a set of documents, soon known as the Pentagon Papers, to the *New York Times*. This classified report on the early years of the war—compiled by Ellsberg and others for Secretary of Defense Robert McNamara—exposed top-level obfuscations about U.S. involvement in Vietnam going back to 1945. The Nixon administration sued the *Times* to stop publication, but lost in a landmark Supreme Court ruling. Covert operatives tied to the White House and known as the "Plumbers" tried to discredit Ellsberg. The Plumbers' pattern of illegal activities later led to the Watergate scandal and Nixon's resignation in 1974.

Events on the ground in South Vietnam offered little relief. In 1971, ARVN troops launched an attack on enemy forces massing in Laos along South Vietnam's border. Despite extensive U.S. air support, the operation failed, and North Vietnamese troops forced ARVN into a chaotic retreat. Fearful that South Vietnam would collapse before the war could be ended on desirable terms, Nixon and National Security Adviser Henry Kissinger stepped up talks with the North Vietnamese. They also opened new diplomatic channels with the Soviets and Chinese in an attempt to pressure Hanoi from multiple angles. In early 1972, the urgency of such efforts became apparent when PAVN launched a powerful offensive of its own, the Easter Offensive. Massive amounts of U.S. bombing in North and South Vietnam denied Hanoi a military victory. Both sides renewed efforts to negotiate an end to the war.

Peace talks led by Kissinger and North Vietnamese diplomat Le Duc Tho made major progress in the early fall of 1972. Nixon and Kissinger aimed to sign an agreement before the presidential election in November, but when South Vietnamese President Nguyen Van Thieu rejected its terms—particularly the proviso allowing North Vietnamese troops to remain in South Vietnam—progress halted.

In November, Nixon won his re-election in a landslide. In order to prove his commitment to Thieu, the president ordered renewed bombing of North Vietnamese cities in December. After these deadly "Christmas bombings," negotiations reopened in Paris. In January 1973, the peace treaty crafted the previous fall was signed and the United States withdrew.

Fighting nevertheless continued in Vietnam until April 30, 1975, when PAVN forces captured South Vietnam's capital, Saigon. The attacks provoked a chaotic evacuation of remaining Americans, as well as some of the military, support staff, and civilians affiliated with the South Vietnamese regime. Although the war was finally over, its profound legacy in Southeast Asia and the United States was only beginning to unfold.

UH-1D from the 226th Aviation Company flies a defoliation mission in the Mekong Delta, 1969. Photograph, Bryan Grigsby / National Archives at College Park, MD

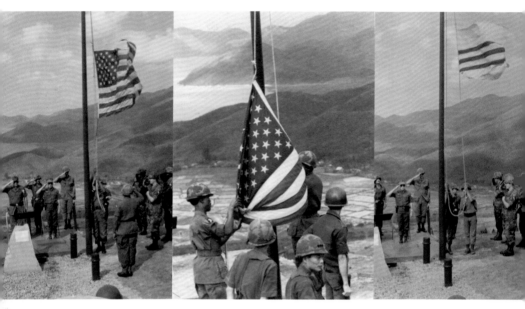

U.S. flag is lowered and South Vietnam government flag raised over Fire Support Base Tomahawk during a ceremony turning the base over to the ARVN 5th Regional Forces from the U.S. 101st Airborne Division, 1971. Photographs, Brett Fakenstine / National Archives at College Park, MD

Changing of the Guard

In July 1969, Nixon announced that twenty-five thousand Americans would come home from Vietnam by the end of the summer. By initiating a series of gradual troop withdrawals, the president hoped to show progress on the warfront and stem protest at home. He planned to decrease American involvement and use South Vietnamese government forces in their stead—a policy called "Vietnamization" and championed by Secretary of Defense Melvin Laird.

U.S. troops started turning over control of their command posts and equipment to ARVN, including fire support bases like the one pictured here. Though ARVN had been fighting alongside Americans for the entire war, Vietnamization aimed to hand South Vietnamese soldiers primary responsibility for combat operations. The United States continued to provide material aid and extensive bombing support, and well into 1971, American troops engaged in substantial combat.

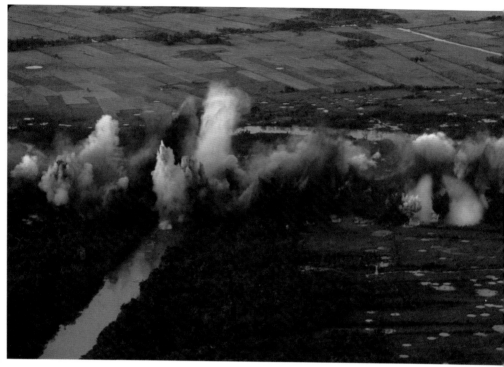

B-52 strike, 1969. The Vietnam Center and Archive at Texas Tech University

Expanding the Air War

As part of his military plan, President Nixon continued the air war in North and South Vietnam and Laos, and expanded bombing into Cambodia. With this strategy, he hoped to pressure Hanoi into negotiating an end to the war on American terms while simultaneously answering domestic calls for de-escalation. The strikes impeded the enemy's progress, but also caused carnage and political instability throughout the region.

The accelerated bombing campaign included extensive use of B-52s as well as other aircraft. It took the B-52s twelve hours to travel the 2,600 miles from Andersen Air Force Base in Guam to Vietnam. Each strike typically decimated a swath of territory the size of the National Mall in Washington, D.C.

By the war's end, U.S. planes had dropped over seven million tons of explosives on Southeast Asia, three to four times more than all of the bombs dropped by all combatants during World War II. Over half of this total was dropped on South Vietnam.

In bombing runs over North Vietnam, U.S. pilots and crews faced the North's antiaircraft defenses. Over three-quarters of the war's more than seven hundred American POWs were airmen.

Hamburger Hill

In May 1969, the U.S. Army's 101st Airborne Division, assisted by ARVN's 1st Division, assaulted enemy fortifications on "Hill 937." This was the the army's name for Ap Bia Mountain in the A Shau Valley, an important infiltration route for PAVN soldiers entering South Vietnam from Laos. The battle raged for ten days over steep jungle terrain, involving close fighting in harsh weather conditions. Meanwhile, air strikes, napalm, and artillery wrought widespread devastation. U.S. and ARVN forces eventually dislodged the North Vietnamese at great human cost to both sides, earning this battle the name "Hamburger Hill."

Given the high casualties, many Americans were outraged when the military abandoned Hill 937 soon after the operation ended. Senator Edward Kennedy saw Hamburger Hill as a symbol of the war's futility, telling Congress, "I feel it is both senseless and irresponsible to continue to send our young men to their deaths to capture hills and positions that have no relation to ending this conflict."

101st Airborne troopers rush a wounded comrade to a dust-off chopper on Hamburger Hill, 1969. © Topham / The Image Works

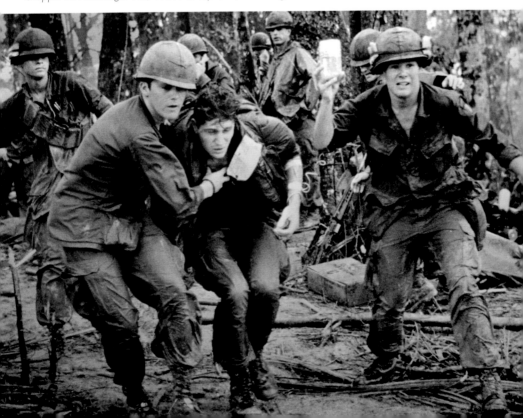

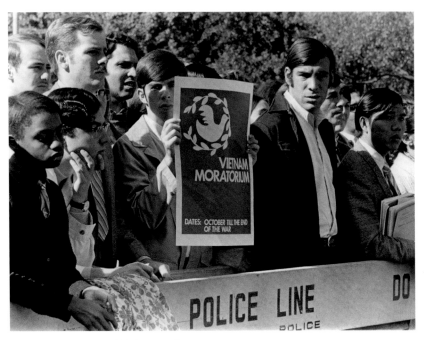

Vietnam Moratorium in Washington Square Park, New York City, 1969. © Diana Davies / Swarthmore College Peace Collection

Moratorium to End the War

Millions of Americans participated in the Vietnam Moratorium. On October 15, 1969, in towns and cities across the nation, demonstrators skipped work and school, halting "business as usual" to attend silent vigils, discussions, and other events. Many mainstream Americans joined the call for peace for the first time, responding to distressing reports about the war and the Moratorium's broad appeal. "You didn't have to be out on the barricades," explained organizer Sidney Peck. "It could be wearing an armband, it could be honking your horn. No matter what your politics were, if you were against the war, here was a chance to express it."

A sign of the growing weight of antiwar sentiment, the Moratorium was endorsed and supported by many establishment figures, including diplomat W. Averell Harriman, former Supreme Court Justice Arthur Goldberg, head of the United Automobile Workers Walter Reuther, and a bipartisan group of nine senators and representatives. In its aftermath, *Time* magazine noted, "Nixon cannot escape the effects of the antiwar movement."

President Richard Nixon and Chief of Staff H. R. Haldemann
photographed with mail received after Nixon's "Silent Majority" speech,
1969. Courtesy The Richard Nixon Presidential Library and Museum (NARA)

Nixon's Silent Majority

Concerned about the public's opinion on Vietnam and the growth of the antiwar movement, on November 3, 1969, President Nixon addressed the nation, asking for support. He outlined his plan for peace negotiations, explained the logic of his war policy, and argued that an immediate withdrawal from Vietnam would be disastrous to his goal of achieving a "just and lasting peace."

The president's speech and carefully plotted public relations campaign aimed to generate public enthusiasm for his administration's war policies. Characterizing the antiwar movement as a "vocal minority," Nixon insisted that the mainstream of American society—the "silent majority"—was on his side. His appeal for unity and patriotism, including his statement that only Americans could defeat Americans, resonated with many who viewed his speech on TV.

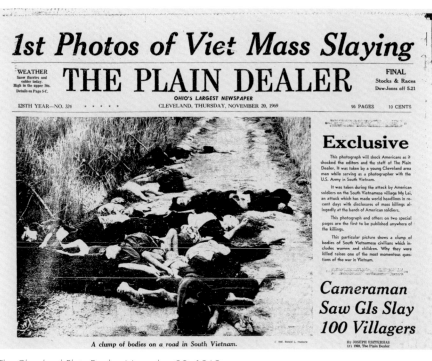

The Cleveland Plain Dealer, November 20, 1969.
Courtesy of the Cleveland Plain Dealer

The My Lai Massacre Comes Home

News of what became known as the My Lai Massacre commanded national attention in the fall of 1969. Journalist Seymour Hersh broke the story. Then images of the massacre taken by U.S. Army photographer Ron Haeberle were published in the *Cleveland Plain Dealer* and *Life* magazine.

Over a year earlier, on March 16, 1968, a company in the U.S. Army's American Division had attacked a small village in South Vietnam as part of a campaign to clear the enemy from the countryside. Over the course of a few hours, American soldiers killed hundreds of civilians of all ages. No punitive action against them was taken and the murders, rapes, and more covered up. A despairing letter to Congress from a recently returned soldier finally triggered an army investigation in April 1969.

Many Americans were shocked that such atrocities could occur. The army's own findings in 1970 attributed blame to the officers and commanders whose orders falsely depicted the Son My area as "an armed enemy camp" and who exhibited "an almost total disregard for the lives and property of the civilian population." In the courts-martial that followed, only Lieutenant William Calley was convicted of murder.

Shelton Bunn (#131), Roosevelt Alexander (#264), and Mike Boland (#1) listen to a radio broadcast of the draft lottery at Phelan Hall, University of San Francisco, 1969. Jerry Telfer / Courtesy of UC Berkeley, Bancroft Library

Draft Lottery

During Nixon's first year in office, the system of selecting men for the draft changed to a random lottery. The new system aimed to reduce inequities by eliminating deferments for new registrants. It also aimed to lessen the anxiety of young men subject to the draft by shortening their period of eligibility to one year. The president believed that this change in policy would reduce protest against the war.

On December 1, 1969, the first draft lottery since 1942 was broadcast on radio and television. To determine the order of induction, officials drew blue plastic capsules—each representing a day of the year—from a fishbowl, using birthdays to assign order-of-call numbers to all men within the eligible age group.

Young men throughout the country listened anxiously as the lottery randomly determined their likelihood of enlistment. Of the men in this photo, Mike Boland's "number one" position meant he would almost certainly be drafted, while Shelton Bunn and Roosevelt Alexander could breathe easier.

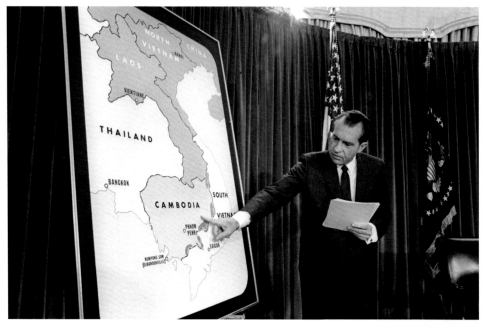

President Richard Nixon during a press conference on Vietnam and Cambodia, 1970. Jack Kightlinger / Courtesy The Richard Nixon Presidential Library and Museum (NARA)

Cambodia Campaign

On April 30, 1970, President Nixon announced imminent military operations in Cambodia. Norodom Sihanouk, Cambodia's ruler, had tried to keep the country neutral by treating with the Americans and the North Vietnamese. But Sihanouk had just been deposed by the U.S.-friendly General Lon Nol. Now Lon Nol's forces were battling North Vietnamese and NLF troops who used Cambodia as a supply line and refuge.

Nixon and his advisers determined that sending soldiers into Cambodia would protect Lon Nol and eliminate the cross-border threat. In May and June, U.S. and ARVN troops conducted operations in Cambodia, buttressed by heavy American artillery and bombing of the region.

Among Americans who saw this as an expansion of the war, the outrage went deep, extending from college campuses to the halls of Congress. Senators John Cooper (R-KY) and Frank Church (D-ID) proposed their Cooper-Church Amendment, a congressional initiative to forbid further action in Cambodia and de-escalate the war. A revised version was enacted in January 1971, preventing U.S. ground troops from entering Cambodia. The bombing, however, continued until halted by Congress in August 1973.

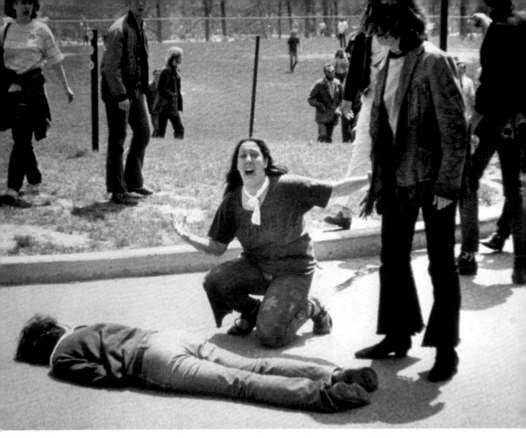

Fourteen-year-old Mary Ann Vecchio screams over the body of twenty-year-old Jeffrey Miller, shot at Kent State University, May 4, 1970. John Paul Filo / Getty Images

Kent State Shootings

The nation's campuses erupted in protest immediately upon hearing Nixon's announcement about Cambodia. At Ohio's Kent State University, local and state officials reacted to the demonstrations with particular force. After a tumultuous two days that saw bottle throwing, tear gas, and the burning of the Reserve Officers' Training Corp (ROTC) building, the governor sent the National Guard to occupy the campus. On Monday, May 4, when demonstrators at a rally did not disperse as ordered, the National Guard fired into the crowd. Four students were killed and nine others wounded.

Public reaction to the shootings ranged from support for the National Guard's actions to anguish and outrage over their excessive use of force. A Gallup poll conducted shortly afterwards found that 58% of Americans blamed the students. The folk rock group Crosby, Stills, Nash, and Young released a protest song, "Ohio," whose lyrics painted a picture of a nation torn apart by violence: "Gotta get down to it, soldiers are cutting us down ... Four dead in Ohio."

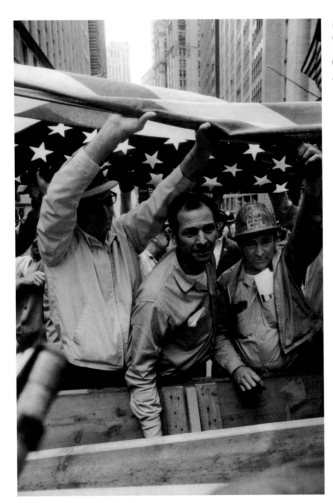

Hard Hat Riot, NYC

In response to the Kent State shootings, New York mayor John Lindsay called for a day of reflection so New Yorkers could consider what the campus killings meant "for the future and fate of America." On May 8, 1970, the flag at City Hall was flown at half-staff and schools canceled citywide. About one thousand antiwar protesters gathered in the downtown financial district.

Shortly after noon, two hundred construction workers arrived at the rally, encouraged by union leaders to shut it down. They carried American flags and chanted "U.S.A.—all the way!" Violence erupted as construction workers taunted and assaulted the antiwar demonstrators and bystanders, injuring more than seventy in what became known as the Hard Hat Riot.

A combustible mix of disagreements around the war and other social and cultural issues had fueled the incident. Although the riot helped turn the hard hat into a symbol of blue-collar opposition to the protests, polls showed that Americans with less formal education were consistently more likely to oppose the war.

Back from Vietnam

Even as the war raged on, servicemen returned to the U.S. after completing their one-year tours of duty. Boarding commercial jets, they arrived home within just a day or two of leaving the war zone.

No single description can capture the variety of homecoming experiences for the nearly three million men and as many as eleven thousand women who served in Vietnam. Yet certain experiences were all too common:

a sense of displacement, an ambivalent public welcome, the debilitating effects of war memories and injuries, and the onset of perplexing illnesses that later would be linked to exposure to defoliants like Agent Orange.

Moreover, the United States had changed. Social unrest, political chaos, an economic downturn, and increasing dissent over the war they had fought complicated the transition to civilian life for many veterans.

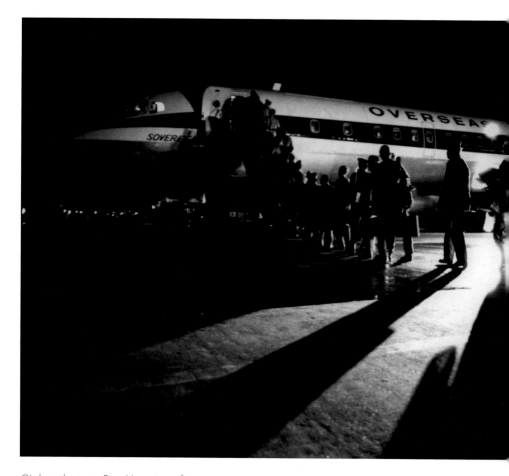

GIs board a jet at Bien Hoa airport for the flight home, November 1971. David Burnett / Contact Press Images

"When the coast of Vietnam went away and we were out over the ocean, you could almost feel a visible release of tension in the aircraft, just because you were out of there and you were out of danger."

Rodney Kilduff

"Coming home was rather emotional. My father was beside himself. He wasn't one for showing too much emotion at certain things, but he was taken aback, and it was good to see him."

Jimmy Bacolo

"Old college friends had huge questions about the war. Why in Vietnam? Why did you volunteer? I couldn't answer. I didn't understand myself. The mood of the country didn't make you feel any better about it. There were a lot of protests. That's when I started going to antiwar demonstrations."

Thomas DuBose

"Nobody wanted to talk about it, so eventually I just wound up withdrawing and socializing with other veterans because nobody else cared about what we'd been through or what we were experiencing."

Frank Gutierrez

"Not a day goes by that I don't have a flashback or a thought about Vietnam, about the incidences, the missions, or just about the simple smell. It's what holds me back from being a whole man. It's the guilt—it's the killing, it's the not caring about human beings at that one little time, that year, that just keeps coming back and back."

Herbert Sweat

"I still have this little trick. I don't do it every night, but when I lie down, if there's something bothering me, I say, 'You're warm, you're dry, and there is no one shooting at you.'"

Robert Ptachik

Committee to Help Unsell the War

Ira Nerken, a twenty-year-old Yale political science student, developed the idea for this advertising campaign after the broadcast of the CBS documentary *The Selling of the Pentagon* in 1971. Like many Americans who watched it, Nerken became concerned about the government's role in shaping the public's understanding of the Vietnam War. If the war could be "sold" to the American people, he concluded it could also be "unsold."

Nerken teamed up with David McCall, president of a Madison Avenue advertising agency, in order to create the Committee to Help Unsell the War. More than three hundred writers, artists, directors, and producers from nearly fifty ad agencies donated their time to create 125 antiwar print advertisements, 33 TV commercials, and 31 radio spots. The ads ran on hundreds of local television and radio stations, and appeared on billboards and in magazines and newspapers across the country.

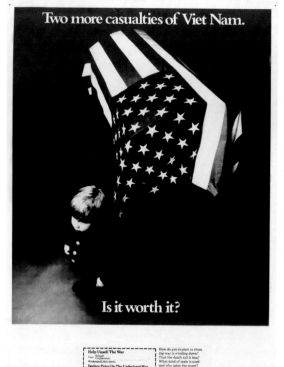

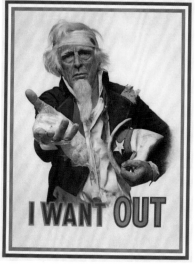

Committee to Help Unsell the War posters, 1971–1973. Library of Congress, Prints & Photographs Division

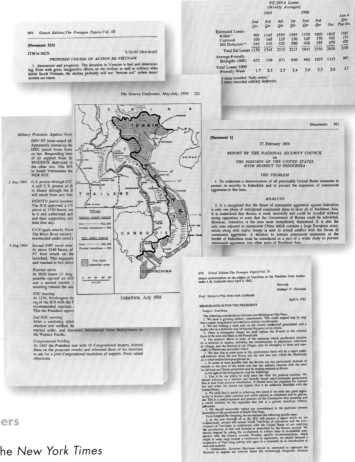

Excerpts from the Gravel Edition of the Pentagon Papers, inserted into the congressional record by Senator Mike Gravel from Alaska, 1971. New-York Historical Society Library. Courtesy of Beacon Press

The Pentagon Papers

On June 13, 1971, the *New York Times* published the first of many excerpts from a 7,000-page government-produced report, soon known as the Pentagon Papers. Secretly prepared under Secretary of Defense Robert McNamara and titled *United States–Vietnam Relations, 1945–1967*, the papers provided an insider's account of U.S. involvement in Vietnam. Daniel Ellsberg, one of the report's contributors, leaked the documents to the *Times* and other major newspapers. He believed he had a moral duty to share information that showed how successive presidents misled the public about Vietnam.

Outraged by the leak, the Nixon administration pursued a federal injunction to prevent the publication of any more excerpts, arguing that their release threatened national security. The injunction led to a landmark Supreme Court case—*New York Times Co. v. United States*. On June 30, 1971, the justices upheld freedom of the press as protected by the First Amendment. The court ruled 6–3 in the newspaper's favor, deciding that the government had failed to meet the burden of proof to justify censorship. The following day, newspapers nationwide resumed publishing the Pentagon Papers.

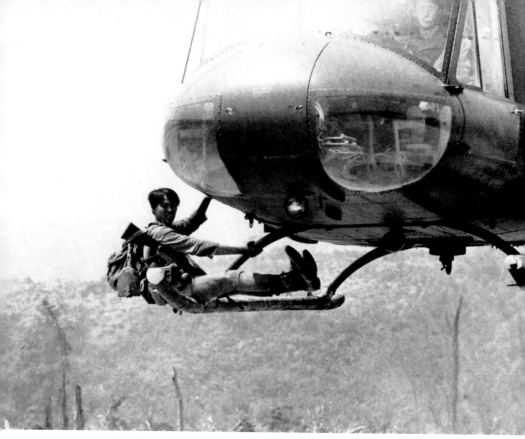

A South Vietnamese trooper clings to the skid of a U.S. helicopter in the ARVN evacuation from Laos, 1971. Holger Jensen / Associated Press

Laos Campaign

In early 1971, at the direction of American military leaders, the South Vietnamese government launched an offensive into neighboring Laos. The purpose of Operation Lam Son 719 was to crush enemy forces within Laos and sever supply lines along the Ho Chi Minh Trail. Nixon hoped a successful campaign would prove that Vietnamization was working and prevent an enemy offensive before the 1972 election.

Following strikes by American jets, fifteen thousand ARVN soldiers poured across the Laotian border. U.S. ground troops were prevented from entering Laos by earlier congressional action.

Although the United States provided massive artillery and air support, ARVN troops were unable to overcome fierce opposition from PAVN. When President Thieu ended the operation earlier than planned, his army's retreat turned into a rout.

Publicly, Nixon projected victory, declaring in a televised speech, "Tonight I can report that Vietnamization has succeeded." Privately, though, he realized that ARVN was still unprepared to stand on its own.

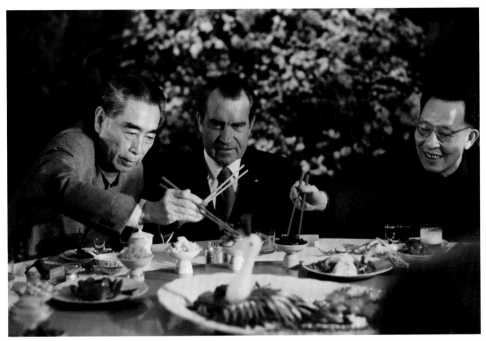

President Richard Nixon eats with Zhou Enlai and Chang Chun-chiao, 1972. Bettman Archive / Getty Images

International Diplomacy: USSR and China

By 1971, neither combat nor negotiations with Hanoi had brought the U.S. closer to the peace with honor that Nixon had promised. Meanwhile, antiwar activism among the public and in Congress was on the rise, a North Vietnamese offensive threatened, and the election of 1972 loomed. A favorable settlement in Vietnam was thus one incentive that led the president and his national security adviser to accelerate diplomacy with the Soviet Union and China. They sought to convince these Cold War powers to pressure the Hanoi government to negotiate an end to the Vietnam War on terms acceptable to the United States.

In February 1972, Nixon became the first American president to visit the People's Republic of China. During his week-long stay, he met with Communist Party Chairman Mao Zedong and Premier Zhou Enlai. Just months later, Nixon traveled to Moscow for talks with Soviet leaders. Historians dispute the effect these efforts had on the war, but by initiating a new era in international diplomacy, Nixon undoubtedly boosted his standing with the American public. That fall, he won his re-election in a landslide.

North Vietnam's Easter Offensive

In March 1972, North Vietnamese forces initiated one of the largest conventional military campaigns of the war. The Easter Offensive aimed to capture and occupy territory, strike a decisive blow against the South Vietnamese government, and secure a stronger position at the diplomatic table where negotiations were stalled. Multiple PAVN divisions assaulted U.S. and ARVN positions. By this time, American troop strength had dropped to about sixty-five thousand, with only a small number in combat units.

The scale and intensity of the attacks alarmed Nixon and Kissinger. In response, Nixon ordered a new round of ferocious bombing in North and South Vietnam. Although the offensive was ultimately stopped, it brought large numbers of North Vietnamese troops into South Vietnam. Many of these soldiers remained in the South, even as diplomatic negotiations to end the war resumed.

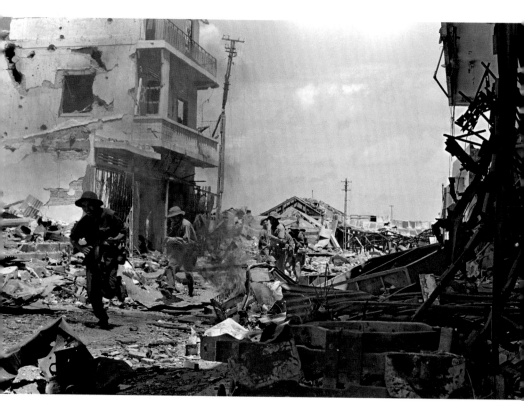

North Vietnamese troops run through the rubble of Quang Tri City, 1972. © Vietnam News Agency

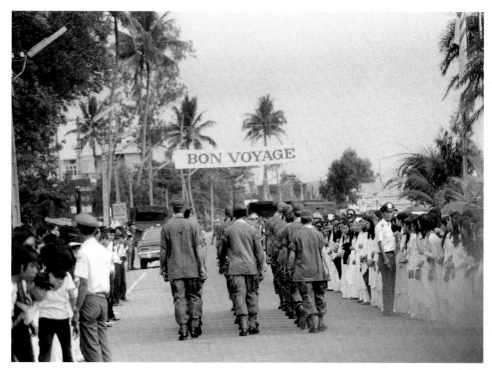

American soldiers depart Danang following a farewell ceremony, 1973. Associated Press

Paris Peace Accords

The Paris Peace Accords effectively ended U.S. involvement in the Vietnam War in January 1973. The last American combat soldier left the country that March, and 591 American prisoners of war returned home.

Earlier, a step forward in ongoing peace talks had come when Nixon announced that the U.S. would withdraw its forces from South Vietnam without requiring that North Vietnam do the same. In exchange, North Vietnam agreed to release all remaining U.S. prisoners. But talks stalled over other issues, and both sides tried to use the battlefield to gain advantage at the negotiating table.

In the fall of 1972, a further advance toward peace had been made when Hanoi dropped its insistence on removing South Vietnam's leaders as a condition of any settlement. After Nixon and Kissinger overcame resistance from South Vietnamese President Nguyen Van Thieu, who felt betrayed, an agreement was reached.

National Security Adviser Henry Kissinger and Vietnamese Politburo member Le Duc Tho, the agreement's chief negotiators, were awarded the Nobel Peace Prize in 1973. Tho declined to accept the award, saying that "peace has not yet really been established in South Vietnam."

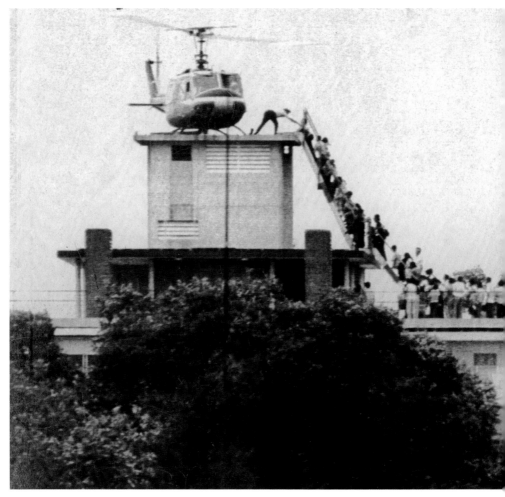

An Air America helicopter crew member helps evacuees at 18 Gia Long Street, Saigon, 1975.
Hugh Van Es / UPI Photo Service / Newscom

The War Ends

The peace agreement's ceasefire quickly disintegrated as fighting resumed in South Vietnam after the U.S. departure. In early 1975, North Vietnamese forces launched what became known as the "Final Offensive," aimed at toppling the South Vietnamese government. Marshaling large numbers of troops and heavy firepower, they rolled south toward Saigon. Hanoi expected the campaign could take two years, but ARVN defenses collapsed with astonishing speed. By the end of March 1975, PAVN had captured major cities like Hue and Danang.

As the enemy advanced on the capital city, American officials evacuated remaining U.S. civilian and military

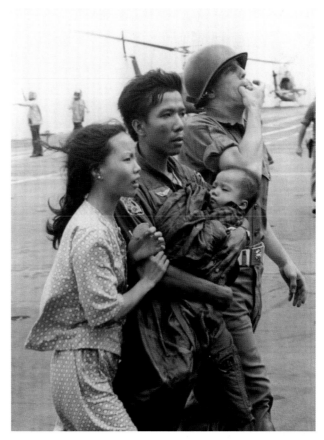

A U.S. Marine escorts a South Vietnamese helicopter pilot and his family to the USS Hancock during the evacuation of Saigon, 1975. National Archives at College Park, MD

personnel. Tens of thousands of South Vietnamese civilians, most of whom had been associated with the southern government, also made their escape. On April 30, 1975, North Vietnamese forces took control of Saigon. The NLF flag was raised over South Vietnam's presidential palace as American helicopters hastily made their exit.

The year 1975 also marked the beginning of a refugee exodus, during which more than two million people fled their homelands in Laos, Cambodia, and Vietnam—1.4 million of them eventually arrived in the United States.

WHY DOES THE VIETNAM WAR MATTER?

More than forty years have passed since the Vietnam War came to an end, but its far-reaching impact continues to reverberate today. The war remains a living memory for people around the world, many of whom bear its lasting physical and psychological wounds. The societies of Vietnam, Cambodia, and Laos still suffer from the millions of casualties, mass flight, and upending of political systems caused by the war. In the United States as well, the war left a legacy of pain and a powerful imprint on the nation's politics and culture. The fundamental questions it raised, the deep divisions it created, and the capacity for civic engagement it revealed echo throughout American life. With profound global and national repercussions, the Vietnam War stands as a signal event in the history of the twentieth century.

In Southeast Asia, the human and environmental devastation of the war years remains evident. Unexploded bombs and landmines that litter the countryside have killed and injured citizens of Vietnam, Laos, and Cambodia in large numbers every year since the war ended. The widespread use of the chemical defoliant Agent Orange, an herbicide used by American forces for crop destruction, has proved extremely dangerous to human health and the environment. One of the war's cruelest legacies, Agent Orange has been blamed for cancers, traumatic birth defects, and other serious health problems in both Vietnamese and Americans. In the United States, veterans' groups won historic legal actions seeking medical treatment and government accountability for their wartime exposure.

The war has cast a long shadow on American life. The conversion to an all-volunteer fighting force ended the draft and dramatically altered the relationship between American citizens and the military. Vietnam-era phrases such as "staying the course," "quagmire," and "the light at the end of the tunnel" have become permanent fixtures in the discourse of war. The term "Vietnam Syndrome," first used in 1980, has come to describe the American public's misgivings about overseas military involvements and concerns about the nation's international reputation: Can the United States use its force effectively? Humanely? And since its end, the Vietnam War has been the prominent subtext of a more divisive era in U.S. politics with Americans fiercely debating

the lessons to be drawn from the war and the issues it continues to raise—from foreign policy and media freedom to the role of public dissent and the meaning of patriotism.

Cutting through these political divisions, the American soldier in Vietnam has emerged as a powerful symbol. In 1982, the Vietnam Veterans Memorial opened in Washington, D.C., where visitors gaze upon a wall nearly 500 feet long etched with the names of the 58,315 U.S. service members who lost their lives in Vietnam. Veterans who did return from Vietnam, like those from previous wars, often struggled with the damaging psychological effects of their experiences. In the 1970s, a veteran-led campaign about the newly named Post-Traumatic Stress Disorder (PTSD) finally led to its formal recognition.

The Vietnam War has also permeated the world of popular culture, the subject of countless books, films, television programs, and other media. Best-selling books such as Michael Herr's *Dispatches* (1977) and Tim O'Brien's *The Things They Carried* (1990) tell searing stories of U.S. soldiers fighting in Vietnam. Films including Francis Ford Coppola's *Apocalypse Now* (1979), Oliver Stone's *Platoon* (1986), and Stanley Kubrick's *Full Metal Jacket* (1987) have had a powerful impact on how Americans think about the war. A new generation of U.S. writers such as Viet Thanh Nguyen and graphic novelist GB Tran are telling stories that foreground Vietnamese, including those who moved to the United States as refugees in the war's aftermath.

In the twenty-first century, the war's complicated legacy continues to unfold. Vietnam presented a deep challenge to the nation's self-image of moral authority and military invincibility. The war may be in the past, but the questions raised by America's many years of military involvement in Vietnam are as alive as ever.

Sources of Quotations

p. 19, "An act of aggression..." Harry S. Truman, "Radio and Television Address to the American People on the Situation in Korea," July 19, 1950. The American Presidency Project, http://www.presidency.ucsb.edu.

p. 22, "You have a row of dominoes..." Dwight D. Eisenhower, "The President's News Conference," April 7, 1954. The American Presidency Project, http://www.presidency.ucsb.edu.

p. 31, "I believe this resolution..." William A. Williams, ed. America in Vietnam: A Documentary History (New York: W.W. Norton and Company, 1989), 239.

p. 34, "I looked at it as something..." Interview with Timothy Vail (OH0445), Vietnam Archive, Texas Tech University.

p. 36, "They wanted to leave a little piece..." Interview with Jerry Barker. Courtesy of Art and Lee Beltrone, Vietnam Graffiti Project, Keswick, VA.

p. 40, "Let me say finally..." Martin Luther King Jr., "In a Single Garment of Destiny": A Global Vision of Justice, ed. Lewis V. Baldwin (Boston: Beacon Press, 2012), 160.

p. 43, "You lived together..." Nathalie Nguyen, South Vietnamese Soldiers: Memories of the Vietnam War and After (Santa Barbara, CA: Praeger, 2016), 110.

p. 51, "It seemed as if..." Martin Luther King Jr., "Beyond Vietnam," April 4, 1967. The King Encyclopedia, http://kingencyclopedia.stanford.edu.

p. 58, "We have been too often..." Reporting Vietnam, Part One: American Journalism 1959–1969 (New York: The Library of America, 1999), 581.

p. 59, "Serious talks..." "President Lyndon B. Johnson's Address to the Nation," March 31, 1968. LBJ Presidential Library, http://www.lbjlibrary.org.

p. 59, "The whole world is watching." Todd Gitlin, The Whole World is Watching: Mass Media and the Making and Unmaking of the New Left (Berkeley: University of California Press, 2003), 187.

p. 60, "They'd have eleven hundred rounds..." Interview with Richard Shippen (OH0528), Vietnam Archive, Texas Tech University.

p. 60, "You'd hear them shooting..." Interview with John Hargesheimer (OH0293), Vietnam Archive, Texas Tech University.

p. 61, "It became necessary..." "Major Describes Move," New York Times, February 8, 1968.

p. 63, "...mired in stalemate." Reporting Vietnam, 581.

p. 66, "Bring America together." "Transcript of the Statement of Nixon Pledging to 'Bring America Together,'" New York Times, November 7, 1968.

p. 70, "And I pledge to you..." Richard Nixon, "Address Accepting the Presidential Nomination at the Republican National Convention in Miami Beach, Florida," August 8, 1968. The American Presidency Project, http://www.presidency.ucsb.edu.

p. 74, "I feel it is both senseless..." Congressional Record: Proceedings and Debates of the 91st Congress, vol. 115, pt. 10 (Washington, DC: U.S. Government Printing Office, 1969).

p. 75, "You didn't have to be out..." Nancy Zaroulis and Gerald Sullivan, Who Spoke Up? American Protest Against the War in Vietnam 1963–1975 (New York: Doubleday, 1984), 265.

p. 75, "Nixon cannot escape..." "Moratorium: At War with War," Time, October 17, 1969.

p. 76, "...just and lasting peace." Richard Nixon, "Address to the Nation on the War in Vietnam," November 3, 1969. The American Presidency Project, http://www.presidency.ucsb.edu.

p. 77, "...an armed enemy camp." Report of the Department of the Army Review of the Preliminary Investigations into the My Lai Incident, vol. 1 (Washington, DC: U.S. Government Printing Office, 1970).

p. 81, "For the future and fate..." "Activity Stepped Up Here," New York Times, May 7, 1970.

p. 83, "When the coast of Vietnam..." Interview with Rodney Kilduff (OH0297), Vietnam Archive, Texas Tech University.

p. 83, "Coming home was..." Philip Napoli, Bringing It All Back Home: An Oral History of New York City's Vietnam Veterans (New York: Hill and Wang, 2013), 142.

p. 83, "Old college friends..." Richard Stacewicz, Winter Soldiers: An Oral History of Vietnam Veterans Against the War (New York: Twayne Publishers, 1997), 111.

p.83 "Nobody wanted to talk about it..." Interview with Frank Gutierrez (OH0078), Vietnam Archive, Texas Tech University.

p. 83, "Not a day goes by..." Napoli, Bringing It All Back Home, 167.

p. 83, "I have this little trick..." Napoli, Bringing It All Back Home, 180.

p. 86, "Tonight I can report..." Richard Nixon, "Address to the Nation on the Situation in Southeast Asia," April 7, 1971. The American Presidency Project, http://www.presidency.ucsb.edu.

p. 89, "Peace has not yet..." "Tho Rejects Nobel Prize, Citing Vietnam Situation," New York Times, Oct. 24, 1973.